MICHAEL CRAIG-MARTIN

A RETROSPECTIVE 1968-1989

WHITECHAPEL

The exhibition has been organised by the
Whitechapel Art Gallery and will be shown from
10 November 1989 – 7 January 1990

Sponsored by Montblanc

With additional support from
The Henry Moore Foundation

Cover:
Reading (with Globe), 1980
Printed on Aarque Ultrafine Draft Film,
donated by UDO Cannon Graphics

THE MONTBLANC SERIES

Montblanc is pleased to join forces with the Whitechapel Art Gallery in presenting this major retrospective of the work of Michael Craig-Martin.

This is the second in the Montblanc Series of Whitechapel exhibitions presenting the work of British artists. In Autumn 1988, the inaugural exhibition in the Montblanc Series showed the sculpture of Richard Deacon, winner of the 1987 Turner Prize and one of the most acclaimed sculptors working today.

Montblanc's arts sponsorship programme was launched in 1987 to support important developments in contemporary art, literature and design, and to bring contemporary work to a wider audience. The Montblanc Series at the Whitechapel Art Gallery is the most significant event in this continuing programme and represents a unique initiative in arts sponsorship.

LENDERS TO THE EXHIBITION

The artist
Australian National Gallery, Canberra
Janice and David Blackburn
Jessica Craig-Martin
Ferens Art Gallery: Hull City Museums and Art Galleries
Alex Gregory-Hood
James Hopkins
Jacobson Townsley & Co.
N. Medhurst
Southampton City Art Gallery
Dr. and Mr. Michael Harris Spector
The Trustees of the Tate Gallery
Ulster Museum, Belfast
Waddington Galleries
Private collection

CONTENTS

FOREWORD

CATHERINE LAMPERT

To an unusual degree, Michael Craig-Martin's work depends on the spectator. Indeed, only civilised human intelligence could be expected to grapple with the dilemmas of non-opening, hinged boxes, mirrors that reflect other people, and distilled line drawings made of black tape. Watching the works for this retrospective, his first, being assembled and reconstructed, we have admired Craig-Martin's fresh, respectful relationship to his own art and to the profession of artist. Objects are made to be exhibited more than once and are thus stocked with formidable questions and visual ambience. It is not irrelevant that the studio where he lives consists of workshop/basement surmounted by an immaculate gallery with high, vaulted ceiling.

The idea for this ambitious exhibition was Nicholas Serota's and together with the artist he defined its scope and set its place within the Whitechapel's policy of showing outstanding British artists in the same manner and depth as their foreign contemporaries. It was his view that the assembly of apparently diverse works in an exhibition covering a twenty year period would reveal the consistent threads in a line of enquiry that probes deeply into visual, physical and linguistic questions.

Before the term 'installation' was fashionable, Craig-Martin was conceiving work for given contexts, and several of the first presentations took place at the Rowan Gallery in the late sixties and early seventies under the enlightened aegis of Alex Gregory-Hood. During the past decade Leslie Waddington has been a strong advocate of Craig-Martin, and the Whitechapel is grateful for his exceptionally generous assistance. We are also grateful for the help of other members of the Waddington Galleries, particularly Tom Lighton, Sarah Shott and Kate Lloyd. Valuable help and advice has also been given by Keith Davey at Prudence Cuming Associates, Liam Gillick and Gerard Williams in the studio, and throughout from Mark James, Nikos Stangos, Richard Shone and other close friends of the artist.

Lynne Cooke is known for her ability to revisualise existing art through the maker's eyes and therefore account for its original arguments and objectives while broadening the story to examine, in a finely calibrated way, the implications of the leading theorists of recent times, here for example Cage and Sontag. Her present essay accomplishes this difficult task especially successfully and also finishes with a bold definition of Craig-Martin's position and individuality. The Whitechapel is grateful to Lynne Cooke and equally to Robert Rosenblum who has used his own informed view of the differences between the visual arts in America and Britain to go beyond first impressions. In the process of this probing dialogue he pays tribute to the artist's importance which is still underestimated and, we believe, finally ready to be recognised outside this country.

The Whitechapel owes a great deal to Montblanc. Their decision last year to support a series of one person exhibitions of British artists of distinction has allowed us to plan ahead, to gather together exactly the work we needed for the exhibitions, and then to produce substantial catalogues likely to have a long life. Participation in the Montblanc Series will come to be, I am sure, an indication of an artist's immediate and lasting significance. A parallel kind of encouragement came from the Henry Moore Foundation who recognise the important contribution made by artists who do not fit the orthodox definition of sculptor, as is true of Craig-Martin whose influence as a teacher and pioneer of new thinking is so visible in the work of younger artists.

Michael Craig-Martin has immersed himself in all aspects of preparing this show. Joanna Skipwith, the exhibition co-ordinator, and I, together with other members of the Whitechapel staff, are very grateful to him and have found the collaboration an especially happy and fulfilling one.

THE PREVARICATION OF MEANING

LYNNE COOKE

Admittedly, it's true that 'knowing something' doesn't involve thinking about it – but mustn't anyone who knows something be capable of doubt? And doubting means thinking.[1]

LUDWIG WITTGENSTEIN

An Oak Tree was presented at the Rowan Gallery in London in 1974. Comprising a glass of water set on an ordinary bathroom shelf, some nine feet above the ground, it was accompanied by a leaflet containing an interview in which the artist was cross-questioned about the piece. In this he explained to his interrogator that what he had done was to 'change a glass of water into a full-grown oak tree without altering the accidents of the glass of water'.[2] When questioned more closely, he elaborated: 'It's not a symbol. I've changed the physical substance of the glass of water into that of an oak tree . . . I didn't change it's appearance . . . The actual oak tree is physically present but in the form of the glass of water.'[3]

Critics were quick to link the underlying concept to the act of transubstantiation which takes place in the Mass when the bread and wine become the body and blood of Christ, a reading with which the artist does in general concur.[4] But in one sense at least, reference to transubstantiation offered only partial explanation. More important was the fact that in this work Craig-Martin asserted his belief in the impossibility of an art that is purely materialist in basis. Paradoxically, this was done via a strictly materialist approach: 'The Oak Tree, it seems to me, deals with the most essential characteristic of art, and the only really essential one, which is an aspect of faith and an aspect of thought and, because it's a visual art, what it looks like, about the appearance of things. And those are the basic constituents of all visual art, all paintings.'[5] Craig-Martin elucidated this further when he described his method of

approach: 'I don't use what I think of as a kind of obscuring technique. I try to do it by being as explicit as possible . . . I mean, art is clearly mysterious and I'm not at all interested in making something which is mystifying.'[6]

What is crucial to this work is the question of belief – both the power of art to construct reality and the question of how this belief comes into being. It is important to note that Craig-Martin did not simply present the glass as an installation with a title that announced the content of the piece. He incorporated the auto-interview as an essential component of the work (hence when the piece is shown abroad, the text is translated into the appropriate language for its audience). That the glass had become an oak tree was not therefore 'given' simply by fiat – by means of a bald assertion on the part of the maker. In place of a naked pronouncement of the artist's will, there is a dialogue in which a self-interview takes place. In the two speakers Craig-Martin incarnated the dual sides of his own position: the dilemma of the believer who is, at the same time, a sceptic. The doubt that inevitably accompanies knowledge, and hence certain types of belief, makes this the very antithesis of blind faith. Knowing as a result of believing is something that has to be worked for, and won; it is not simply assumed. What *An Oak Tree* does most tellingly is to enact this, to stage it, rather than merely assert it. Engagement thus becomes an active affair, an interactive experience during which the spectator is brought to appreciate what it is to partake in the (art) experience, and thereby to apprehend what is for Craig-Martin a crucial component in it.

In response to the query 'Was it difficult to effect the change?', the artist replied 'No effort at all. But it took me years of work before I realized I could do it.'[7] His confession is important in two respects. Firstly it attests to the fact that the realisation was not a Pauline conversion: rather it was the product of a cumulative understanding, one which grew out of previous work and thought. And secondly, that it is a conceptual apprehension – but not necessarily a logical or rational one – which holds the key to the work: it is this which makes visible what is at stake.

There could therefore be no other works of the same type to follow. Repeating the act in different guises could serve no purpose. As it stands it is at once the most rarefied example and the most transparent instance. In this respect Craig-Martin's position was very different from that of Duchamp who, in selecting the first ready-made, discovered that the particularities of choice, and how they were registered, offered sufficient play to permit a number of additional objects to follow. By contrast, had Craig-Martin substituted, for example, a cup of sugar for the glass and then transformed it into a school of fish, it would not have been fundamentally different in principle from *An Oak Tree*. This is because the subject of the work is neither the properties of the glass nor of the tree, but a recognition of the transformative act and, inherent in that, the exercise of belief. Whereas the act of apprehension is normally considered to involve conceptual and perceptual activity, they are, Craig-Martin implies, insufficient in themselves: what is crucial is faith.

In many respects *An Oak Tree* can be seen to be the culmination of the work which the artist had made since first coming to Britain in 1966. Though it differs in content from Craig-Martin's first mature statements, it is none-the-less closely related to them in form and structure. At the same time it marks a radical revision in the relationship between perceiving, conceiving, and then apprehending.

Following his arrival in Bath in the summer of 1966, where he had a contract to teach at the art school for a year, Craig-Martin began making boxes. Constructed from plywood and coated in household paint or formica, they all had commercial hinges and cabinet fittings to allow them to be opened, or (partially) closed, or otherwise rearranged by the spectator. Maintaining the modest scale and form of domestic furnishings, they were generic in character but in fact unique, hand-made to the artist's specifications. Participation was essential to a proper understanding, as can be seen from the different positions that the two identical volumes, *Box that Opens Half-way* and *Box that Never Closes*, may adopt. Their pedigree lay in Minimalism. Craig-Martin had immersed himself in this new aesthetic as it emerged in New York during the early sixties when he was still a student at Yale University School of Art. It was however the *Primary Structures* exhibition, held in New York in April 1966, which fully clarified its achievement for him.[8] In the boxes, which he made immediately on leaving New York, he reinterpreted its premises in telling ways. Both Donald Judd and Robert Morris had employed straightforward cubic solids, fabricated industrially to their specifications, which they presented directly on the floor of the gallery in active engagement with the actual space. These cubic constructions were abstractions: neutral, impersonal, three-dimensional, geometric shapes. Association and reference had been eliminated, it was believed, by the use of a non-referential vocabulary and standardized, manufacturing techniques. The result was a self-referential, autonomous object. But because the radical reduction of incident within the work forced the viewer to examine closely all aspects of his or her engagement when confronting the literal object, the act of apprehension involved a scrutiny which imbricated perceptual and conceptual understanding: the viewer inspected that specific entity in that particular place at that moment in time.

Craig-Martin, too, employed everyday materials in standardized forms, fabricated in a straightforward manner. His boxes were none-the-less not abstract primary structures. They were not objects with a box-like format as were, say, Robert Morris's mirror boxes (*Untitled*, 1965-76, Tate Gallery Collection) which Craig-Martin admired, but real boxes: identifiable, utilitarian objects – though, admittedly ones with idiosyncratic habits of behaviour. They were malfunctional; the lids did not fit, the insides were not hollow, the tops would not fully open. It was precisely this behaviour that served to establish their status as works of art instead of objects of use. Moreover, in most cases, as in *Long Box*, this behaviour was in turn only comprehensible to the viewer if he or she interacted directly with the various components.

In subsequent pieces, comprising a number of identical boxes whose lids were reversed, this question of identity, now defined in terms of sameness and difference, became even more paradoxical. Abstract understanding now proves very different from actual experience – for here Craig-Martin prised the conventional distinction between seeing and reading further apart. To see indicates to apprehend the thing itself, whereas to read means to reach beyond physical attributes in order to establish a relationship with an underlying order: in the latter the subject adopts a critical relationship to the means of expression. In these sculptures, apprehension of the art-work led to a conscious reconstruction of the self as a responding participatory subject.

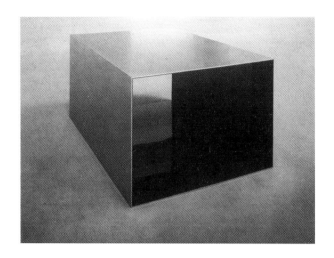

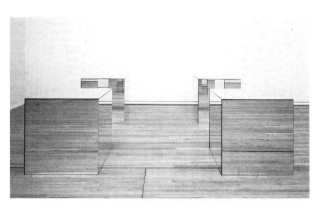

Donald Judd, *Untitled*, 1969
Clear anodized aluminium and violet plexiglass
Saatchi Collection, London

Robert Morris, *Untitled*, 1965/76
4 pieces, mirror plate glass on board
The Trustees of the Tate Gallery

In Craig-Martin's next group of works, which employed balances, this interplay between intellectual understanding and sensory experience again provided the sub-text. And, once again, the artist worked with familiar objects, though this time they were ready-made, mass-produced, store-bought, cheap, new and easily purchased.[9] No transformations were effected; more importantly, their usual functions were no longer interrupted. Many of Craig-Martin's contemporaries, both in Britain and in the United States, were at this time concentrating on the process of making, letting materials do what they wanted and so (largely) determine the final form of the work of art. Craig-Martin, by contrast, began to consider function as roughly equivalent to process. At the same time he turned the current preoccupation with the process of making into a concern with the process of apprehension, treating the physical acts of balancing and weighing as metaphor for intellectual activity. In the *Eight Foot Balance with Two Reinforced Plywood Sheets*, for example, the concept of balance takes on a dual character. It applies to the actual tool, which comes to rest because the wooden sheets are identical, and hence of equal weight. But it alludes also to the action of the two planes in relation to gravity: both heavy sheets stand precariously on narrow edges. Hence the balance attained is not the result of sustaining two equal, free-floating elements, but arises from holding, in precarious equilibrium, two unstable, earthbound components. In conflating these two types of balancing, Craig-Martin's piece establishes a kind of mechanical/metaphorical conundrum.

With the *Six Foot Balance with Four Pounds of Paper*, the old adage concerning the relative heaviness of a pound of feathers and a pound of lead is revisualised, as the image (the illusionistic depiction of the weight, repeated on as many single sheets of paper as was required to make up the equivalent load) is set against reality, the weight itself. The imaged and the actual hang in equilibrium. While conceptually the piece is easily comprehended, experi-

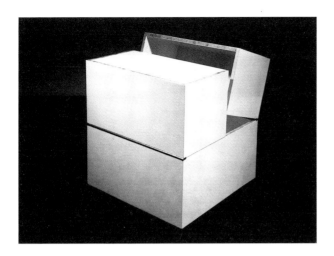

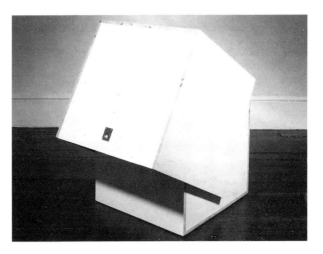

Box that Never Closes, 1967
Painted blockboard
The Swindon Museum and Art Gallery

Box that Opens Half-way, 1967
Painted blockboard
The artist

entially it is complex. Understanding constantly seems undercut by a rush of intuitive, irrational, (dis)belief, which threatens to override, subvert, or otherwise render duplicitous, clear-headed logic. With *Counter-weight Enclosed and Exposed,* two identical halves start to seem very different on account of the effect of the concealing panel. Knowledge again rests precariously on belief – that is, on faith that the title accurately describes the constituents of the piece. The measured tone, if not the lucid demonstrative methods employed in these early works, undergoes a shift with *On the Table*. The expository title is as dead-pan and terse as its predecessors and yet the results are altogether different. Once again the problem Craig-Martin set himself was a typically, if deceptively simple one: how to balance a table in a quantity of water equal to its own weight. Although perfectly straight-forward, the results were simultaneously ingenious and preposterous. Lewis Biggs described the effect well when he stated that it is 'like a scientific demonstration of gravity and mechanics. It adds nothing whatever to our knowledge. It aims instead to return us to the astonishment at the ordinary which direct perception can provide when our knowledge of images and languages is momentarily – like the table – suspended.'[10] The elliptical wit in this conundrum makes it highly memorable and potent. In combining simplicity with clarity without, however, precluding the possibility of absurdity, it attests to Craig-Martin's abiding concern to make statements in the clearest manner possible, together with his growing recognition that this might end in results that were far from 'normal'.

Image and word, language and appearance, are interdependent in the most potentially unsettling ways. Consequently the balance between conceptual understanding, sensory experience and belief is a shifting and continually (re)negotiated one. While these issues came to the fore in Craig-Martin's art at the beginning of the seventies, they reached a kind of climax in *An Oak Tree*. Once again the artist employed ordinary everyday objects, and once

again it was the functioning – the act of transubstantiation in this case – that ensured that the object was perceived as a work of art, though of course recognition was now of a very different order from that which occurred in the cases of the malfunctional boxes and multifunctional balances. Here the functional change was apparent only to the eye of the faithful. What is known and what is seen may be determined on the basis of what is believed.

By 1970 Conceptualism, one of many names that had emerged in the late sixties as part of an attempt to identify and pinpoint the rapid efflorescence of new modes and forms of visual art, had received widespread critical recognition. Whereas Minimalism had been a purely American-bred phenomenon, Conceptualism was not. It sprang up virtually simultaneously in a number of centres in North America and Europe and burgeoned rapidly on this international, cosmopolitan ground swell. When Craig-Martin arrived in England in 1966 Minimalism was virtually unknown except to the few assiduous readers of such American art magazines as *Artforum*. What the British vanguard witnessed in the later sixties was a rapid transition from a Greenbergian formalism, centred around Anthony Caro and the sculpture department of St. Martin's School of Art, to a hydra-headed activity involving process, anti-form, conceptual and land-based activity. Stimulus for this came from various quarters, including an almost complete retrospective of Duchamp's art held at the Tate Gallery in 1966; John Latham's notorious act of reducing Clement Greenberg's *Art and Culture* to goo, an act that led to his dismissal from the staff at St. Martin's; an internal reaction by students like Bruce McLean, Gilbert & George and Richard Long within St. Martin's itself to what they perceived as a rigidifying formalist orthodoxy; and the showing of an international exhibition devoted to the new modes at the ICA in London in 1969, entitled *When Attitudes Become Form*. The peak was reached in Britain, as elsewhere, in 1972 when the Tate Gallery showed contemporary art in force for the first time in an exhibition organised at very short notice, and when, soon after, the Hayward Gallery played host to a well selected and installed show of the key local proponents of this tendency.[11] Curated by Anne Seymour, and entitled *The New Art*, it contained some dozen artists including Craig-Martin. Seymour argued that her protagonists did not constitute a group, nor herald a cohesive movement as such, and Craig-Martin's work certainly bore little direct relation to much on view there. The two clearest groupings comprised, on the one hand, artists who engaged in philosophy and, especially, linguistics in order to examine the central identity and character of the artwork (notable among whom were Victor Burgin, John Stezaker and Art & Language) and, on the other, those who, like Richard Long and Hamish Fulton, were preoccupied with a land-based, nature-oriented art.

Craig-Martin presented two key works in this exhibition. One was an installation, *Six Images of an Electric Fan*, in which a moving fan segregated behind a wooden partition was perceived from half a dozen different positions, including one from below, by means of a series of mirrors set into the wall; none of these views coincided with the actual position of the spectator at that moment. The second piece, *Assimilation* 1971, involved a progression of ordinary objects in what was one of a series of works he made at this time involving clipboards and related articles: a sheet of paper, eraser, pencil, etc. By means of various kinds of permutation, repetition, exchange and extension amongst the elements in the sets – often one item from each group was systematically removed in

order to make up the full complement – Craig-Martin endeavoured to demonstrate that it was not the subject matter per se but the structure, a structure derived from those functional relationships normally operative between these articles, which could become a discourse in its own right and so hold the key to meaning. He later noted: 'My intention in the original piece was to make a work, using real objects, that did not involve tampering with their essential nature as functional objects. No attempt was made to transcend their ordinary reality. I wished to respect the integrity of the objects, to use objects available to everyone, and to use relationships implied by the objects themselves as the structural basis for the whole. Although the piece is perceived visually and 'read' visually, it is not primarily concerned with visual aesthetics but with the use of visual perception to uncover structure and meaning'.[12] His preference at this time for self-contained systems that repeated and/or exhausted themselves was related to the way in which he wished the structure to govern the meaning: leaving nothing over they threw into greater high-light the structural relationships.

Yet equally telling was the fact, of which the artist himself was well aware, that in contrast to previous series of works with balances and boxes, buckets and bottles, there was a less overtly sculptural character to these later works. This was one important respect in which his work could be directly connected to reigning conceptual modes: 'The advantage of the clipboards was that they disengaged me from making sculpture, which was obviously very important. I wasn't interested in doing work that was verbally or mathematically based and although I don't think of the things that I did as straight sculpture, I wanted to move away from that work without ceasing to deal with physical and visual concerns.'[13] Another aspect of his relationship to Conceptualism derived from his concern with utilizing structure as the principal element to determine content. Structuralism was at this moment making widespread inroads into contemporary intellectual thought in Britain: at Oxford, for example, the Wolfson Lectures for 1972 were devoted to the evolution and impact of Structuralism on a number of disciplines, ranging from anthropology to mathematics. In addition, in 1972 Fredric Jameson's noted book, *The Prison-House of Language*, was published, in which he argued that a succession of constantly changing models is largely responsible for structuring the beliefs, values and knowledge of a society rather than internal shifts within the beliefs themselves.[14] While Craig-Martin did not directly engage with this ubiquitous new theory it seems, tangentially at least, to have impinged closely upon his thinking at that time.

Being rooted in the aesthetics of Minimalism, and responding especially to the position espoused by Robert Morris, Craig-Martin's early concerns, to the extent that they had a philosophical source, could be said to have been based in phenomenology: they focussed on the sensory and kinaesthetic as well as on the conceptual response of the viewer in direct confrontation with the (art) object in real space and actual time. Perception was deemed a bodily based activity, one that not only took place in, but was virtually embedded in the flesh of the real world – to borrow a phrase from Maurice Merleau-Ponty, its most celebrated exponent. Along with a number of contemporaries, Craig-Martin developed further this conception of the spectator's role as an active participatory one by taking it into the realm of installation and environmental work. Several months prior to the fan piece shown at the

Hayward Gallery in August 1972, he had constructed a sequence of booths at the Tate Gallery. Called *Faces*, this work comprised twelve discrete compartments. The spectator entered one and looked into a mirror where he or she saw not his or her own face but that of some other visitor to the exhibition who was at that moment occupying another of the adjacent booths. The experience of looking at art, an inevitably voyeuristic activity, became disturbingly so, when the object of scrutiny, in this case the mirror, 'looked' back.[15] As Anne Seymour perceptively wrote of this installation: 'Although the work does not actually constitute a philosophical discussion about the nature of the work of art and its relationship to the world, inevitably the viewer is involved with just such a meditation when he confronts it, or allows himself to be drawn into the trap of its devising.'[16]

Other works from this period were less physically grounded, depending more on image alone, or on text, or on a combination of image with text: compare for instance *Nine Mirrors, Four True Stories* and *Conviction*. In the last of these, each of eight small mirrors attached directly to the wall was accompanied by a handwritten statement and framed separately. The viewer walked the length of the piece scrutinizing his or her image as he or she reacted to the captions. Craig-Martin later recalled that 'These works emerged from an alteration from the concerns of the preceding works with mirrors. In this earlier phase, I had attempted to deal with questions of physical confrontation, either of object, place, self, or others. All were intended to elicit psychological consideration of the physically experienced situation. I decided to try to deal more directly with the question of the psychological confrontation of the viewer with himself.'[17] The mirrors externalise experience, the questions internalise it; the observer in responding interacts actively in order to construct the content, and yet the content is largely determined by the structure. Craig-Martin defined the sequence of experiences which the spectator underwent in such a work as 'recognition, understanding, knowledge and acceptance'. With acceptance comes the implication of conquering doubt, and yet certainty never seems firmly grounded, as the title with its double meaning attests. Conviction may indicate strong belief, it may equally imply, according to Chambers Twentieth Century Dictionary, 'the condition of being consciously convicted of sin'. Since this unavoidable ambiguity interfered with the way in which the reflected image was interpreted, understanding became irredeemably caught up with belief, truth and its antithesis. The work involved a dialogue through which the self constituted itself as part of the act of apprehension of the art-work. It thereby served to enact a kind of moment of genesis in which the self came into being through an act of auto-inspection.

In focussing on language as it interrelates with visual imagery, Craig-Martin's work had certain affinities with that of many of his peers, yet whereas the British artists who concentrated on language tended to use it, as did Art & Language, as a tool for philosophical analysis, Craig-Martin treated it like a given element. In his art it became a familiar everyday entity akin to images and even to mundane artefacts. Its role was to generate quizzical reactions as did the mirror, balances and buckets before it. And once again in its specific instance it served primarily as a vehicle, diverting attention back to the structure of the work, and hence to a more abstract speculation. Language was perceived as no more the centre of revealed truth than was any material artefact directly encountered.

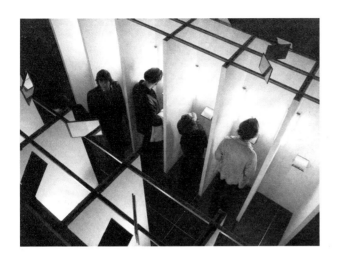

Faces, 1972
Installation with mirrors for 7 *Exhibitions*, Tate Gallery

List of statements used in *Conviction*, 1973
Mirrors, tape and handwriting on wall
The Trustees of the Tate Gallery

Juggling what was experienced and what was known, the visualised with the psychological, became a constant preoccupation, almost a congenital trademark of Craig-Martin's art at this time. His particular use of language – not to question the nature of art, nor the identity of the artist as creator, but to highlight the role of the spectator in completing the work – gave his art a distinctive orientation of its own. Yet its marked singularity owed as much to the ways in which Craig-Martin realised his ideas, as to the character of the ideas themselves. And crucial to this was his exceptional history and formation. Brought up in the United States and educated at Yale he had reached maturity as an artist in comparative isolation in Britain. From this unique conjunction of circumstances he fused influences and ideas in a highly personal fashion.

At this stage it was less the fact that he was obviously in thrall to Wittgenstein (as were so many others at this point) that should be remarked, nor even his fascination with John Cage, but rather the way in which he responded to both, simultaneously. The conjunction produced something highly unusual. Craig-Martin had long been interested in Cage, admiring in particular his *Lecture on Nothing* from 1949/50. [18] In this essay the composer made evident to his audience the nature of the structure of the piece through their experiencing of it. Hence what was actually discussed, the nominal subject, was virtually reduced to nothing: it was the laying bare of the structure that was most radical. Also in this text Cage crisply formulated his celebrated credo that structure without life is dead, but that life without structure is unseen. By contrast, in Wittgenstein's philosophy, and especially in his book *On Certainty*, published posthumously in 1969, Craig-Martin found a challenging, limpid and aphoristic discussion of the concept of certainty, and of its relation to knowledge, to truth, and to belief. Many statements could be cited from the Viennese philosopher's text, but the following may serve to give some indication of both the central content of

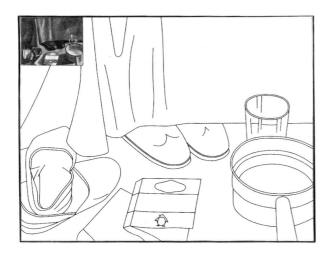

Painting and Picturing, 1978
Oil and tape on canvas
The artist, courtesy of Waddington Galleries

Red Interior with Figure, 1987
Aluminium, painted steel rods and oil on canvas
Waddington Galleries

the text and his aphoristic mode of expression: '61... A meaning of a word is a kind of employment of it. For it is what we learn when the word is incorporated into our language . . .65. When the language-games change, then there is a change in concepts, and with the concepts the meaning of words change . . . 83. The *truth* of certain empirical propositions belongs to our frame of reference . . 253. At the foundation of well-founded belief lies belief that is not founded.'[19] Like both Cage and Wittgenstein, Craig-Martin sought to embody, not merely illustrate, the ideas in his work and, in operating by example, to require the active participation of the observer rather than treating him or her as the passive recipient of didactic instruction. Equally important was their commitment to the use of ordinary, familiar matter as their preferred materials, and their dispassionate openness to, and involvement in, the actualities of everyday experience. And all three worked from specific instances, producing succinct, dense embodiments that none-the-less retained a speculative and conversational tone. Common to all three is a consummate formal abstemiousness, an elegant fastidious wit, and a disarmingly (and seemingly) nonchalant, pared expression. It was thus not just their ideas which had appealed to him but the forms in which they were manifest.

One consequence of Craig-Martin's shift in focus in the early seventies was a displacing of the overtones of absurd logic that had imbued a number of his earlier works, overtones which reverberated with echoes of Beckett.[20] In its place a lighter note, more epigrammatic and spritely, intervenes, as if the timbre of one Irish writer had been replaced by that of another, this time that of Oscar Wilde. For also formative on Craig-Martin's thinking was Wilde's essay 'The Decay of Lying' which he had first read as an adolescent.[21]

Aside from the specific content of this essay (an argument for an art for art's sake aesthetic), it is the general tenor of Wilde's approach, the way he manifested his thoughts, that must have appealed to the young Craig-

Martin. Characteristic of Wilde's writing is a stance that betrays an elegant ease and lightness of touch, a svelte presentation that never stoops to didactic or dogmatic assertion, and a love of aphoristic statement. Wittgenstein speculates in a fireside manner, Cage never hectors but elusively beguiles and Wilde disarms with his wit. It is the achievement of a tenor and form owing much to the combined influence of these three writers that above all distinguishes Craig-Martin's mode of Conceptualism from that of his peers, both in England and abroad.

For him, Conceptualism was always an engaged art, one which centred on the relationship between experience and knowledge, between belief and understanding, a relationship that was necessarily clarified through a self-conscious act of apprehension. In place of a systematic intellectual analysis which sought certainties, Craig-Martin revealed knowledge to be precarious and tentative, constantly prey to the encroachment of doubt. This problematic interaction between image, word and object peaked in *An Oak Tree*, bringing together a series of ideas which had received various kinds of treatment over the past six years.

I I

When pictures were extremely rare, there would have been something venerable in the captured, imaged presence of almost any object. But we now live amid a proliferation of pictures of all sorts . . . Because pictures are no longer extraordinary it has become more necessary to think about depiction itself in order to obtain some distance toward the images that surround us, to keep ourselves from getting so lost in what is pictured that we forget that there is something at work in us that allows pictures to be.
The painter may make a picture, but what makes his product into a picture is the fact that someone takes it as such. We have to look beyond the painter to understand pictures philosophically.
To ask what lets it be a picture at all, and what it is for it to be a picture is to raise a philosophical question. And of all the achievements and relationships involved in picturing, only this one – the one which is philosophically the most important – does not have a name in the ordinary English use of the word 'picture'.[22]

ROBERT SOKOLOWSKI

AROUND THE MID-SEVENTIES Craig-Martin's interest began to diverge, as much in response to two seminal essays which he read at this time, as to events in the art world. One was Michel Foucault's 'Las Meninas', the other the Catholic philosopher Robert Sokolowski's article, 'Picturing'. The culmination of his thinking was again presented in the form of an exhibition at the Rowan Gallery. This took place in 1978. Very shortly afterwards Craig-Martin himself published an article which did not accompany the works that constituted the exhibition, nor was it quite simply a text, an exegesis of his underlying thinking; it may best be described as a verbal complement to the sequence of wall drawings which had emerged over the previous months.[23]

The subject of Foucault's essay, which forms a frontispiece to his theoretical treatise, *The Order of Things: An Archaeology of the Human Sciences*, is the question of representation.[24] In a masterly account of Velázquez's painting,

21

an account that is written as though it were merely a simple description of the elements contained within the work, Foucault argues that the subject of the picture (ostensibly the Monarchs whose place must, perhaps first unwittingly but then increasingly self-consciously, be inhabited by the spectator who views the paintings) is absent, and hence that representation of itself excludes the subject of its examination. But what seems most to have engaged Craig-Martin was the conjunction of method and structure so that articulation of itself becomes an act of interpretation. Moreover, in *Las Meninas*, perhaps above all other paintings, the act of articulating what it is that the picture represents serves simultaneously as an interrogation of the viewer.

Much of this could be connected to Sokolowski's thinking, for he stressed the fact that naming, articulating and picturing are all interdependent, that they are all intimately connected with each other. In addition, and equally importantly, they are disclosures; they are, to borrow his term, 'achievements'. Neither organic tensions, nor processes that occur automatically in human beings, they are conscious experiences that have to be actively generated.[25]

Since Craig-Martin constructed his text, 'Taking Things as Pictures', which he based on Sokolowski's, as a series of tightly interlocking aphorisms, it is difficult to extrapolate from it. Aside from its actual content, what is most revealing about it compared with the auto-interview is its affirmative tone: the whole is couched in terms of statements, statements of fact or truth:

'Picturing is a precondition of picture making.

Picturing is the more essential achievement.

The artist's product is a picture because someone takes it as a picture . . .

Pictures do not merely *refer* to the pictured, but make the pictured *present*.

There is a difference between a thing and its presence

. . . Picturing enables us to experience the presence of a thing without the thing itself.'

And he concludes

'Language, signs, and pictures are not just aspects of our experience of the world.

They are intimately related to how and what we experience, and what we understand by that experience.

Names, pictures, and signs would be impossible without each other.'[26]

The show at the Rowan comprised four very large drawings made directly onto the gallery walls with adhesive, black tape. Each depicted several domestic artefacts, ordinary everyday items such as a hammer, sandal, book, table or ironing board, all rendered in neutral outline, the angles chosen to ensure that each form was realised as three-dimensionally as possible. Over the previous two years Craig-Martin had built up a 'dictionary' of dozens of these drawings of mundane objects. To make one he began by sketching from life, then refined the contours so

that it took on the character of an 'objective' depiction akin to that found in sales catalogues, or children's drawing books. Several would be placed over each other to make a composition, the artist experimenting with different combinations before reaching his final design. Next he transferred the composite outline drawing to a single, clear, acetate sheet. From this he made a slide which could be projected onto a wall to the required size, a size that was adjusted to the specifics of the situation. The projected images were then traced in tape of the required thickness, the tape providing a means of ensuring an inflectionless, linear firmness otherwise difficult to achieve. Although they used the wall, these works were not site specific but could readily be transferred to another context and the dimensions of the drawing altered to suit.

Previously, when employing mundane objects in his art, Craig-Martin had sought them in stationery and hardware shops, or from DIY emporia. Many of the same types of objects were to reappear in his wall drawings, though the lexicon gradually extended to include large-scale, domestic items such as a piano, or hi-tech goods like the Walkman and television set. However the range and diversity are such that they cannot easily be pinned down, nor classified: they are not simply consumer durables, for while some are valuable, many are not. Moreover, some are obviously contemporary, others not, some ubiquitous, others comparatively scarce, and so on.

In the first show, in 1978, all the objects were treated as if they were transparent. By overlapping one item directly over another, no narrative connection was suggested; rather the viewer became involved with trying to isolate one artefact from the remainder, striving to hold it visually in mind and not lose it in the flickering mêlée of intersecting, abstract lines. Questions as to what would register most strongly in the visual field, and how the various competing images were to be extricated, now came to the fore. Shifts in sense and meaning had to be continually fought for and remade. Individual images appeared to be as much in front of as behind one another, depending on the beholder's focus of attention. Caught in this visual web of ambiguity and constant oscillation, the viewer is led to inspect his or her own perceptual habits, codes and conventions.

This set was followed by a second, including the Ulster Museum's *Untitled Wall Drawing* of 1979 in which certain of the lines that represented overlapping sections of the elements (glass, hammer, ladder, saucepan, table) were removed. This had the effect of creating a complex mélange, an interweaving that locked the components into a taut conjunction. In the third group the images in front clearly overlapped those behind, seen for example in the Tate's *Reading (with Globe)* of 1980. Changes in scale and viewpoint further complicated the internal relationship. Grasping what was there involved a close scrutiny of the notion of visuality not just of vision. This in turn implied a reflexive awareness of the kind that was outlined in Sokolowski's text. Whereas previously belief had been a crucial prerequisite of comprehension, conditioning sensory and mental responses, now the focus had shifted to other conceptual factors equally essential to it. When in the first mirror works, such as *Faces* of 1972, Craig-Martin exchanged images for objects, he was still engaged with the physical context and hence with the viewer as a bodied perceiver in an actual space. By the end of the decade his whole focus had become much more abstract; he now concentrated on apprehension at the level of mental or imaginative achievement as an ability that

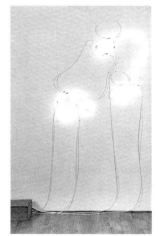

Turning Pages, 1975
Neon
Margate Public Library

Reading Light, 1975
Neon
The artist, courtesy of Waddington Galleries

humans develop and cultivate over and above automatic motor and organic reflexes.

Their large scale and direct transmission on the gallery wall thus rendered them insistently real as presences though in other ways they might be said to have no actual existence, being physically no more than discrete pieces of tape adhering to the architecture of the space. They were thus as abstract, as non-physical, as mental acts, though like mental operations, firmly rooted in organic matter. But just as the nature of the relationship between mental acts and neural processes remains mysterious, similarly, the relationship between the viewer and the wall drawing is a disembodied ambiguous one, given that the drawing has a resonant presence but no actuality.

Craig-Martin came to these, amongst his finest works, via a series of other quite different pieces. Whilst with hindsight these others might be said to have prefaced the wall drawings, they were in fact quite self-contained and did not lead either inevitably or even logically to them. The first of what might be considered foreshadowings occurred with the neons which he constructed in 1976. They marked a significant shift away from using actual objects towards representation. Of the four that survive, *Pacing, A Short Film for Zeno, Sleight-of-hand* and *Reading Light,* it is the last which is the most prophetic. The laconic title identifies by way of a 'double entendre' the activity (the action in time), as well as naming the object. This ambiguity is compounded by the impression that the light is itself reading the book as well as providing the illumination by which both book and image are read. Although less diagrammatic or hieroglyphic than the others this neon, too, is at once object and image, for Craig-Martin left the wires and other parts of the mechanism clearly evident and refrained from plunging the gallery into darkness to enable the shapes to be read more sharply. As the statement which accompanied the show pointed out, the neons can be considered simultaneously as signs, drawings and films. In *Reading Light* presence starts to be divorced from

24

the thing itself, and picturing is treated as an activity that can be separated from the objects which generate it.

The impetus for this use of neon stemmed from Craig-Martin's first public commission. Invited to make an outdoor sculpture for a library in Margate, he came up with the idea of an open book, its pages turning, to be situated like a large sign above the entrance to the building. Whereas billboards and signage may have played a role in suggesting this solution and, indirectly, Pop art too, his proposal was not an instance of low cultural means and motifs being employed in the service of high art, as a British interpretation might have suggested. For Craig-Martin the mundane artefact is not something of lowly status, an inferior by-product, but the most convenient source for a meditation on reality. When in the later sixties many artists were seeking 'poor' or low-cost stuff as their raw material, some chose organic materials like sticks and rocks, others man-made substances like cloth, latex, or sheet rubber. For Craig-Martin who wanted to use objects in preference to unformed matter, their nearest counterparts were such mundane artefacts as the ubiquitous milk-bottle (which since it is continuously recycled no one really owns), galvanized buckets and such-like. Neon, a pervasive, familiar, modern material, seemed a natural extension of this.

Further arising from his growing preoccupation with the notion of picturing was a work called *Painting and Picturing*, executed in 1978, in which he incorporated into the upper left-hand corner of the large blank canvas a small found object, an anonymous painting of a still-life rendered in a conventional realist style. It was one of a number of works which he made in this vein in 1976. What distinguished *Painting and Picturing* from the others, however, was the fact that Craig-Martin 're-drew' in outline on the remainder of the surface the principal components of the found picture. The work of the unknown amateur, whose activity followed very orthodox and predictable conventions and genres, was set in opposition to that of the modern artist, but in this case an artist who subsumed his individuality and signature style into impersonal graphic draughtsmanship and dutifully copied the composition of the earlier practitioner. Interestingly, many of the items in this somewhat strange still-life, set perhaps on the floor beside the bed, recur as favoured items in the repertoire that Craig-Martin himself developed soon after. Art as mimesis, as a product of schematic and conventional styles of realism, becomes the subject of the work through the act of copying, in one borrowed style, a work in another, equally banal. There is, none-the-less, something unusually tentative for Craig-Martin about this particular work, something that smacks of the self-conscious exploration of a thesis. If in certain respects it was prophetic of the wall drawings which were first realised later that same year, it was the wall drawings that wove these various threads within the work into an unexpectedly rich whole.

Since it was the achievement of picturing that Craig-Martin was primarily concerned about in his wall drawings, he strove to eliminate all narrative and anecdotal relationships within the compositions. Similarly, he eschewed any attempt to render the objects symbolic. Nonetheless the desire to connect these juxtaposed items is difficult to gainsay as Norbert Lynton has argued: 'Perfect images as they are, the drawings do not add up. Yet our reasoning minds refuse to let go. We feel that if the objects do not form satisfactory relationships then they must

form unsatisfactory ones (the open tin is at war with the sandal, the hammer with both, etc.). A visual confrontation that seemed at first celebratory reveals itself as a trap constructed out of our mental system.'[27] The following anecdote which Craig-Martin recounts with bemusement vividly demonstrates the near irresistibility of this temptation: 'I was installing a wall drawing in a museum, tracing the lines in tape on the wall. The work included images of a table, a filing cabinet, a ladder, a chair, a light bulb, an ice-tray, a book and a globe. Nearing completion, I was approached by a woman who introduced herself as a guide. She explained that she would be bringing tours through the galleries discussing the works on view, including mine. "I understand everything about your drawing except for one thing", she said, "I don't understand the ice-tray".'[28] However, what the artist strove for was not an engagement with puzzling images but an immersion in the drawing itself, drawing which is encountered as an immaterial entity but which none-the-less has an imposing presence to it. 'In our century the work of art has entered the space of the viewer rather than the viewer entering its space. To accomplish this, artists have employed three general modes: abstraction, materiality and conceptualization. Picturing has had little place in this scheme. I am trying to find a way of retaining the experience of immediate presence for the viewer, through picturing alone, and without resort to the other three modes.'[29] By affixing them directly to the wall Craig-Martin eliminated not only the standard role of the picture as a window onto a world beyond, but he removed the traditional framing that inevitably comes with a sheet of paper or a piece of canvas; the drawing shares the viewer's space, it becomes part of the furnishings of the room.

Perception is however no longer situated in the experiencing body embedded in time and place, as it was presumed to be in the boxes and other early sculptures. Now it has become disembodied, disincarnate, fractured and multiple. It therefore implies that certain fundamental revisions have taken place in the notions of vision and visuality, and hence in the production of subjectivity. In a recent lecture, entitled 'Scopic Regimes of Modernity', Martin Jay drew a fundamental distinction between vision (sight as a physical phenomenon) and visuality (sight as a social phenomenon): that is, between the mechanism of sight and its historical techniques, between the datum of vision and its discursive techniques.[30] Borrowing Christian Metz's concept of a scopic regime, he analysed the ideal, typical characterisations, the dominant visual models that constitute the visual culture of modernity. Jay contends that the dominant model was forged through a joining of Renaissance systems of perspective with a Cartesian subjective rationality. The resulting three-dimensional, rationalised space is surveyed by a static observer whose single viewpoint is externalised and disembodied for it is located outside the pictured space. The dispassionate eye of this neutral privileged beholder embodies an ahistorical, disinterested, disincarnate subject, one which is entirely exterior to the world it claims to know from afar. This monocular eye can be construed as either transcendental and universal, as it traditionally was, or as contingent and specific as it tends to be now.

This model is radically different from that proposed by Merleau-Ponty's phenomenology, which defines perception as a physically based phenomenon, one in which the viewer is inextricably enmeshed in the texture of the actual world, in the specifics of time and place. Other models in addition to this have also been adumbrated, most

importantly that of the Baroque which provided a significant challenge to the normative visualisations of Cartesian perspective. It managed to unpack certain of its underlying values by revelling in contradictions between surface and depth – by disparaging attempts to reduce the multiplicity of visual space into any one coherent system, into a homogenous illusion of three-dimensional space. Also typical of the Baroque was a preference for a plurality of monadic viewpoints, for ambiguity over literal clarity, for vertiginous experience over static equilibrium. It provided an, admittedly temporary, denaturalizing of Cartesian perspective, one which has echoes in certain contemporary practices.

Craig-Martin's wall drawings constitute a related attack on the still orthodox conventions of this modern scopic regime. He turns them inside out by disorientating the viewer, rendering contingent, multiple, and conflicting the certainties conventionally offered by Cartesian perspective. While relating immediately to the images entangled in his or her space, the spectator fails nonetheless to locate him or herself definitively in relation to the illusionistic contexts. Moreover, these can neither be measured nor logically comprehended being shorn both of stable co-ordinates and of a framing structure. His works draw on the ideal typical characterisations of the modern scopic regime only to invert or otherwise unmask them, exposing them as precarious and contingent fictions, fictions through which vision, and with it the subject, is socially constructed.

By the end of the seventies a sea-change had occurred, not just in British art but much more widely as the implications of Conceptualism were gradually fully absorbed, and the art-works appropriated by both the gallery and market systems. Moreover, a backlash had set in. In England it can be charted through a series of shows, some of which were explicitly devised to restore the dominance and hegemony of painting and sculpture in their most conventional definitions. The first of these was Andrew Forge's *British Painting '74*. It was followed by *The Condition of Sculpture*, held at the Hayward Gallery in 1975 and curated by William Tucker, which acted as a deliberate riposte to Seymour's show. In 1976 R.B. Kitaj's *The Human Condition*, a kind of polemic for art based on the figure, was staged, but the real crunch came with the Hayward Annual selected in 1977 by Michael Compton, Howard Hodgkin and William Turnbull. The storm of rancorous protest that erupted around this exhibition clearly revealed a hitherto dormant but deep-seated antagonism between various competing factions within the British art world, notably the orthodox painting lobby which dominated the exhibition and, increasingly, the English art-scene as a whole, and a group of critics including Caroline Tisdall, Paul Overy and Richard Cork who were regarded by many of the painters as hostile since they were known supporters of art with overt social relevance.[31] Although several of those artists connected with Conceptualism (and the other related trends featured in Anne Seymour's show, among them Craig-Martin) were included in the 1977 Hayward Annual, their work was generally eclipsed and disregarded in the ensuing fracas, and the issues they raised side-stepped. By the end of the decade they found themselves increasingly isolated against a background of growing conservatism and establishment domination.

The parallels that might be drawn between Craig-Martin's work and that of other British artists at the close of the seventies seem more fortuitous than consequential. Whereas Patrick Caulfield had long employed a similar

vocabulary of objects drawn from everyday life, first rendered in conventionalised graphic modes and then, in recent years, juxtaposed as different styles of representation and therefore different codes for reality, this always took place within the sanctified conventions of painting. For him painting was 'a given', it was only the various visual languages and what they signified that might be examined, not the art-form itself. Equally distinct and singular was the project of Richard Hamilton which had its roots in Pop art but had subsequently evolved from there to a wider and deeper examination of the languages and modes of representation. Hamilton's fascination with technology, with modern inventions that provided novel forms and languages of representation was a broadly cultural one at heart, and though he shared certain interests with Craig-Martin, little direct interaction can be perceived in their practices. Between Craig-Martin and the younger sculptors emerging in the early eighties, such as Tony Cragg and Bill Woodrow, the affinities were more superficial than substantial. They chose their raw material in part for reasons of economy, and in part for its associations of contemporaneity and of urban life-styles. Recuperation and transformation, acts which carried symbolic meaning, were central to their activity. For Craig-Martin, by contrast, no question of salvaging items from the realm of kitsch or mundane matter for the revered spheres of high art had ever been involved in his choice of pre-existing, everyday objects. And whereas these sculptors preferred discarded and often worn or damaged objects, his were familiar and pristine, devoid of both a past history and any intended sociological commentary. Although, to him, they were not in themselves significant, collectively these objects clearly did presuppose a specific attitude to reality. It was one that was fundamentally American in its origins, as in its spirit, and thus radically different from that espoused by any of these younger British sculptors.[32]

Craig-Martin was not specifically engaged with the values and anthropology of a throw-away society, for the America he knew when growing up in the years after the war was a thriving mercantile culture, one which did not so much render its key objects obsolescent as revere them as communal icons. As Adam Gopnik has argued, in a statement that Craig-Martin seconds enthusiastically: 'What John Updike has described as the metaphysics of American realism is rooted in this faith – in a transcendental cult of real things and the world as it is. In the European world, where modern art began, realism – the assertion of the object – acts above all as a protest against mystification. That is still the spirit of British Pop – the Chevy tail fin mocking the pretensions of the Tate. But the tradition that we inherit from Whitman and Melville looks to ordinary objects – to Coke bottles and cans of soup as much as to blades of grass and lists of whalers' tools – for something more, something that is itself mysterious'.[33] Updike writes that Whitman hoped to see 'real things assigned the sacred status that in former times was granted to mysteries'.[34] It is a sentiment that Craig-Martin echoed some years ago when he stated: 'The world in front of our eyes is extraordinary. The difficulty is in seeing what is in front of our eyes. The difficulty for the artist is in acknowledging what he sees'.[35] Dealing with the stuff of daily life, with ordinary objects, events and experiences as his subject matter, made Craig-Martin's work immediately accessible, whether his audience pursued the underlying meaning was another matter.

2 8 It is possibly not surprising that at this stage Craig-Martin began to consider returning to New York, and in

1981 he moved there for a trial year. Certain parallels might be drawn between his art and that of several of his friends from Yale, most notably perhaps with that of Jennifer Bartlett, who was also exploring competing and contradictory realist modes and a dazzling variety of styles all of which could be deemed notational if not fully representational. Yet these links were ultimately more tangential than telling, and may owe more to their mutual regard for the work of Jasper Johns than to shared ideals. What Craig-Martin seems to have discovered above all from this year of living in Manhattan was the degree to which he was 'cross-cultured': related, albeit peripherally, to art being made on both sides of the Atlantic. Yet in the end he remained a maverick. Later, he astutely summarised the nature of his relationship with much concurrent activity when he stated: 'I think that the work that I do has always had a kind of acknowledgement of what was going on, what was of interest yet has always been slightly outside of it'.[36]

The wall drawings are clearly keynote works in his œuvre, their place comparable to that marked by *An Oak Tree* nearly six years earlier. Formally, too, they have much in common with it, above all on account of the eloquent brevity in composing, the succinct, elegant austerity of (under) statement that allows complex philosophical issues to be raised but their implications left to the spectator to unfold, if so motivated. Over the next couple of years Craig-Martin explored certain of their implications with considerable ingenuity and finesse.

One consequence was the making of constructed isolated objects, such as the book and umbrella, from thin strips of steel. The resulting three-dimensional sculpture bore virtually no resemblance to the artefact that it represented; the representation lay in the drawing. Read as a plastic object, its form seemed arbitrary as a particular word may when used to name some entity. Next he introduced planes of colour, firstly on canvas and then on sheet metal. Once again the image was partially illusionistic (involving perspectival foreshortening), and partially plastic (a solid metal frame). As found in *The Thinker*, an adroit homage to a classic (art) object, the Rietveld Chair, Craig-Martin's piece appeared to inhabit a kind of physical limbo, a disturbing intermediary zone that belonged neither to drawing, painting or relief, nor to sculpture proper. In partaking of all these orthodox categories but belonging securely to none, the hybrid 'chair' revealed the artificial character of all art, and the arbitrariness of its conventional sub-categories.

With those works which also incorporated coloured panels, Craig-Martin had moved from images of objects to making images become objects, objects that were at once abstract and representational: 'I am very interested in the idea that the drawing, through which one knows immediately what the object is, is only an aspect of the total work. The drawing is not everything to the work, and yet that's the thing that gives you all that information'.[37] The results were works of the most sustained artifice. Blatantly present as images, these objects are also tangible abstractions. The immediacy of the pictorial image is held in tension with the assertive actuality of the abstract sculptural form. Material fact and representation coincide, and yet are radically different, as seen in the way that actual space and a perspectival, illusory space blend as if by legerdemain. But the beholder's decision as to what it is that he or she sees is ultimately less important than the discovery of the route by which that decision was reached. In

this search the motif is revealed once again as little more than an aesthetic pawn, an almost insignificant cipher in the eternal games and strategies devised by representation. This Craig-Martin affected by means of sophisticated subtle statements, statements which cannot easily be paraphrased for they take the form of visual thinking as distinct from simply illustrating philosophical propositions.

I I I

. . . the act of recognition that painting galvanizes is a production, rather than a perception, of meaning.[38]

<div align="right">N O R M A N B R Y S O N</div>

N O R M A N B R Y S O N has recently claimed that perceptual psychology has in effect dehistoricized the relation of the viewer to the painting, making of the act of recognition an event in which painting engenders a production, as distinct from a perception, of meaning. Viewing is thus revealed as an activity which involves transforming the materials of the painting into meanings, a transformation which he claims is perpetual: nothing can arrest it. Vision must be realigned with interpretation rather than with perception. As such, it will necessarily be an incomplete and provisional activity: the observer has become an interpreter.

The series of paintings that Craig-Martin has worked on over the summer of 1989 seems once again to constitute a signal moment in his career. Yet at first glance it may appear surprising because these seem to be quite straightforward paintings and, to date, Craig-Martin's work has consistently eluded orthodox categories. He has never thought of himself as either a painter or sculptor despite the fact that he began his career in the painting department at Yale and that his first mature works were received as sculptures, at least in Britain where the notion of 'object-making' has had, and still has, little currency. It is the looser designation of 'artist' that he prefers, a title that carries with it the possibility of operating in diverse ways, including that of making work which refers to and at the same time critiques those normative categories of painting and sculpture without being in thrall to them. Given this background, his present recourse to painting is unexpected, all the more so since it takes place at a time when the much vaunted return of painting that heralded the onset of the eighties, is clearly in disarray. Yet with closer scrutiny these works begin to seem less and less like paintings and more like objects which are about painting. And, more importantly, they bear on the whole operation of looking, calling attention to the viewer's experience by suspending it, fracturing it, doubling it. Content comes to consist of the various angles, qualities and gradients of seeing: it is not something accruing to the thing seen. More like models of paintings than paintings themselves, these diptychs have a way of seeming to isolate various pictorial tropes and to display them as if they were syntactical entities formed to illustrate some proposition. In consequence they give the impression of being somewhat outside themselves, disarticulating and externalizing the problem at the very moment of addressing it.

With their wide stretchers and large dimensions they are massive objects. Their assertive facticity is

reinforced by the manner in which Craig-Martin uses house paint, applying it with a roller to get a smooth but slightly textured dense surface. The colours, not mixed but taken straight from the sales chart, are selected with an eye to combinations which have little to do with pre-existing aesthetic conventions. The conjunctions are thus shrill, tense, volatile, far from the kind of easy equilibrium and subtle accord often anticipated from painting. Viewed in such quantity and at such a pitch, the effect of so much colour is assertive and confrontational, more akin to an assault than a seduction.

Into the midst of the two vast fields, Craig-Martin inserts a pair of identical drawn objects: a television set, a drawer, a shaving mirror. The method is absolutely straightforward, the drawings similar to those he employed in the wall drawings and subsequent, related works. Yet the effect is uncanny. Colour invades each very differently so that, for example, the television on the more acid green seems lit externally, whereas light seems to emanate from within in the deeper green canvas. The colours are also very unstable, shifting dramatically with changes in the daylight and responding unpredictably to different kinds of artificial illumination. Comparison between the two images in their twin panels is constantly invited, yet because they have been set so far apart they cannot be grasped within a single glance. They start to inhabit different spatial levels, appearing more or less immersed in a plastic space, retreating or alternatively pushing forward into the spectator's realm. This sense of dislocation becomes reinforced by the fact that they are not body-scale. Though approximately life-size, the objects float in fields that are enormous, the whole far too big for comfortable confrontation. Somewhat reminiscent of the kinds of tests used by opticians, the effects might amount to no more than that, were it not for the fact that the whole takes place within what is insistently the arena of modern painting. By such means Craig-Martin sets up an uneasy dichotomy between vision and visuality, between the act of seeing and the social construction of the seen.

That the issue once again rapidly moves from the specific and contingent to the level of abstraction is perhaps most clearly pinpointed in the shaving mirror. The mirror is turned parallel to the surface plane: hence what is mirrored is an expanse of colour as if the mirror were double-sided, as if the viewer could see through and beyond it. Since the support is angled the mirror is both situated in depth and located on the surface. What it reflects therefore coincides with its own surface. The nominal subject becomes the vehicle for fusing the patent reality of the painting as a flat surface covered with colour, and the fiction of picturing, or at least picturing as an act of representation. Worth noting too is the way that this drawing style which has dominated much of Craig-Martin's work over the past decade has roots in Purist painting of the twenties and in particular in the work of Ozenfant and Léger, where it embodies an aesthetic of rationality, precision and machine age ideals. Here logic and rationality, reinforced in the use of a one-point perspective schema, with its premises of a consistent knowable world, for the depiction of the mirror's bracket, are called into question. The contingency of this scopic regime together with the values it subtends have been brought into the open.

These are therefore quite different from that other body of paintings which Craig-Martin made in the mid seventies, when he incorporated small pictures by unknown painters into the surface of a pristine untouched

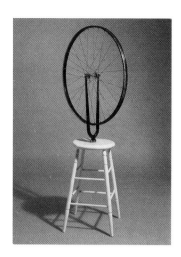

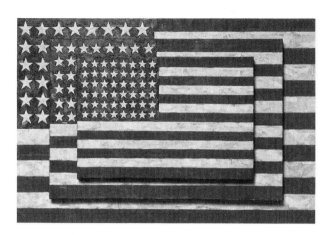

Marcel Duchamp, *The Bicycle Wheel*, original 1913 (lost)
Bicycle wheel on wooden stool
6 versions of which the 6th has an edition of 8

Jasper Johns, *Three Flags*, 1958
Encaustic on canvas, 78.42 x 115.57 cms.
Collection of the Whitney Museum of American Art[39]

canvas. An affirmation of Duchamp's belief that art should be more than a retinal affair, their principal thrust as acts of appropriation was towards the interlinked questions of authority and aura.

The works with Venetian-blinds from 1988 have a somewhat different relationship to the paintings made the following year. They straddle the object/image relationship in a novel way, establishing a literal congruence between the two. At the same time they hark back to the wall drawings in that they belong, albeit ambiguously, to the 'furniture' of the room: they partake of the actual space by frankly being physically part of that site. None-the-less they do presage a substantial rethinking about the nature of the picture surface because, at their most successful, they adopt the standard rectilinear format of painting in addition to making (sly) reference through their geometric configurations and muted colour harmonies to certain celebrated types of abstract painting. (Allusions of this kind occur sporadically throughout Craig-Martin's oeuvre, yet art about art has never been one of his principal concerns.) Moreover, although actually composed from unmodified artefacts, as was much of Craig-Martin's early work, their utilitarian character is countered by the way that grouping them creates a suggestive pictorial field. Janus-like, they look forward while re-stating old concerns.

Possibly much closer to the latest works are certain of the constructions which Craig-Martin devised through 1986-87 in which real and depicted objects were juxtaposed. In several of these, such as *Red Interior with Figure*, the vocabulary of (much) modern painting – flat fields of colour, abstract form, the grid and so forth – is clearly present alongside drawing and imagery, each separated and independently identified. Anti-illusionism, always a factor in Craig-Martin's art, now seems to carry with it a concurrent implacable realism, yet literal reality remains a doubtful concept, as seen for example when it is framed as a fragment in *Side-Step*, 1987. There seems no way of ensuring that

the world of appearances has been exchanged for that of reality in which things simply are the way they are, for there is no knowing how things are.

A constant leitmotif in Craig-Martin's art is his preoccupation with the way things appear, which may or may not indicate the way that things are. His is an art of surfaces, since at least everything crucial is on the surface. He forswears both the introduction of symbolism and the subjective mining of depths. The result is an art that while stating candidly and openly that it conceals no muddy cavities and no obscure recesses, is yet anything but clear. The precariousness, ephemerality, uncertainty and dubiousness of what is known, believed, seen and hence experienced, remains ever present as the underlying and inescapable condition of being.

I V

The idea that depths are obfuscating, demagogic, that no human essence stirs at the bottom of things, and that freedom lies in staying on the surface, the large glass on which desire circulates – this is the central argument of the modern aesthete position, in the various exemplary forms that it has taken over the last hundred years. (Baudelaire. Wilde. Duchamp. Cage.) . . . [The aesthete] is constantly making an argument against depth, against the idea that the most real is latent, submerged . . . The aesthete position not only regards the notions of depths, of hiddenness, as a mystification, a lie, but opposes the very idea of antitheses. Of course, to speak of depths and surfaces is already to misrepresent the aesthetic view of the world – to reiterate a duality, like that of form and content, it precisely denies.[40]

SUSAN SONTAG

SUSAN SONTAG'S INCISIVE EXAMINATION of the writing of Roland Barthes, who is for her an exemplary proponent of the aesthete's position, offers one of the sharpest accounts of this venerable cultural stance. In bringing a deceptively limpid detachment to the claim that surface is as telling as depth, Barthes operates in the best tradition of the aesthete, a tradition that is at considerable remove from the often pejorative implications and superficial values which popular usage of this term conveys. Although Craig-Martin's artistic roots lie in his immediate American background, the combination of sensibility, methodology and judgment which he brings to bear on his artistic practice is strikingly close to that of the paradigmatic aesthete, something not altogether surprising given his admiration for Wilde, Duchamp and Cage, among others. For him it is by means of the oneness of the surface, as much as the explicitness of the object, that the act of apprehension is foregrounded and revealed. In the best tradition of the aesthete, the revelations manifest in such disclosures are neither dogmatically nor didactically propounded. Elliptical and elusive, they are pursued with consummate aplomb to be eloquently and gracefully embodied in works that are marked by a completeness of statement that admits no tinkering and no tentativeness.

Because Craig-Martin clarified very early in his career his central and abiding preoccupations, he has been

able to diversify his activity without diffusing his focus. His œuvre contains a vast array of styles and modes ranging from object sculptures, installations and neons, to paintings and drawings. Despite the constancy of his underlying endeavour he has generally been seen as a maverick, especially in Britain where there is a continual and constant pressure to organise things in ways that are media specific, in relation, that is, to the traditional categories of painting, sculpture, photography, and so on. Nevertheless his career cannot be seen as a seamless evolution. There have been a number of detours as well as doublings back and, as a consequence of his astute awareness of current concerns, a series of transformations which partially break with and partially recoup earlier preoccupations.

That his starting-point was Minimalism, especially the way it was formulated in the work and ideas of Robert Morris, proved beneficial in a number of ways, not least because it gave him the conviction that as an artist, as distinct from a painter (or sculptor), he could choose whatever means he felt were best suited to the realisation of his current concerns. Yet with time it has become increasingly clear that the single figure in the visual arts with whom he has most in common is Jasper Johns. Affinities are discernable at various levels; in their attitudes to subject matter; their non-systematic, non-analytical approach to philosophical questions; their tendency to 'think visually'; and their preoccupation with the constituents of language – visual as well as verbal – and its capacity to convey knowledge and truth.

Writing of the complexities in Johns' work which, he argues, can only be comprehended as a threat to patterns of seeing, feeling and naming, Max Kozloff asserts: 'He (Johns) has created an art of which one major premise is that 'things' have no intrinsic value. Like reflective mechanisms, his works give back to the spectator a spectrum of alternatives by which they may be viewed – without, in fact, containing any 'message' in their own right. But to choose amongst these alternatives, or even to judge what they might be, becomes an experience of imaginative self-discovery which Johns' creations are designed to test'.[41] Much the same might be said of Craig-Martin's. For in his art, too, the subject is commonplace and schematized, the meaning of the objects ostensibly insignificant. Little more than scaffolding on which to hang certain ideas, their prime function is to provide the means to work on other levels.[42] Also central to much of his art are speech and vision which, as components of an integrated function, may mutually reinforce each other but equally may be displacements of each other, resisting and disorientating each other. They are the source for what Kozloff in an apt phrase dubs 'enlightened skepticism'.[43]

Yet by working steadfastly outside the conventions of a given medium and by emphasizing the notion of presence rather than aura, Craig-Martin makes of that sense of presence something which is, if not as overwhelming, at least as strong in its impact as the doubt, duplicity and uncertainty apparently inherent in what is being (visually) stated/conjured/demonstrated. This sense of presence is strongly affirmative, it galvanizes faith, and through it restores a sense of wonder. Irrespective of how fragile and temporary this wonderment might actually prove to be, it confirms Craig-Martin's allegiance to the aesthete's position. Here, above all, he parts company with Johns, a melancholiac – and here, too, may be found the source of that elusive sense of grace which lies at the heart of Craig-Martin's art.

FOOTNOTES

1. Ludwig Wittgenstein, *On Certainty*, (1969), Oxford, 1979, 480, p.63e

2. 'Interview with Michael Craig-Martin', republished p.60 of this catalogue

3. ibid

4. 'Obviously The Oak Tree is based on the concept of transubstantiation which is, in modern life, only found in Catholicism in the Mass. It seems to me a kind of idea, and a form of belief, which was much more common among the ancients as a way of understanding the world. It seems to me to be very close to that area of things which have become isolated in modern life into art, the kind of function that art has been set aside to deal with in modern life. It was originally much more central, and when it was more central, questions like transubstantiation were much more central to it. And therefore, I do think it's a way of understanding about art. . . and how it operates'. (Unpublished interview with Rod Stoneman, 1986)

5. ibid

6. ibid

7. 'Interview with Michael Craig-Martin', op.cit., p.60

8. Held at the Jewish Museum in New York in April 1966, *Primary Structures* brought together a large variety of work, including some by Minimalists as well as by Caro and the New Generation British abstract sculptors. Morris, to whom Craig-Martin was particularly attracted, began publishing his 'Notes on Sculpture' in 1966 in *Artforum*. In Part 2 he adumbrated a key tenet of this American art: 'The better new work takes relationships out of the work and makes them a function of space, light, and the viewer's field of vision. The object is but one of the terms in the newer aesthetic. It is in some ways more reflexive because one's awareness of oneself existing in the same space as the work is stronger than in previous work, with its many internal relationships. One is more aware than before that he himself is establishing relationships as he apprehends the object from various positions and under varying conditions of light and spatial context'. ('Notes on Sculpture, Part 2', *Artforum*, October 1966, p.21)

9. In an interview in 1972 Craig-Martin addressed 'the whole question of object making', contending, 'it seems to me the problem isn't with objects but with how they're conceived, and to me the problem with abstract objects is that the idea of making an independent thing in the world based on a kind of intuitive decision-making and formal understanding has been played out totally. . . . A lot of the most interesting artists have stopped dealing with things altogether. . . . What I've tried is to keep using things but to try to find *another* way that wasn't like that way. The way I've tried to do that is by using literal objects in literal ways. . . . I'm not interested in transcending the object – I want the object to be *just* what it is'. ('Michael Craig-Martin: Interview with Simon Field', *Art and Artists*, May 1972, p.26)

10. Lewis Biggs, 'Between Object and Image', *Entre El Objeto Y La Imagen, Escultura Británica Contemporánea*, Palacio de Velázquez, Madrid, 1986, p.224

11. Held at the Tate Gallery between February 24 and March 23 1972, *Seven Exhibitions* comprised performances, actions, installations, a one-day retrospective and other non-traditional activities by Keith Arnatt, Bob Law, Joseph Beuys, Hamish Fulton, Bruce McLean and David Tremlett, in addition to Craig-Martin. *The New Art*, which took place in August and September of 1972 at the Hayward Gallery, contained work by Arnatt, Art-Language (sic), Victor Burgin, Craig-Martin, David Dye, Barry Flanagan, Fulton, Gilbert & George, John Hilliard, Richard Long, Keith Milow, Gerald Newman, John Stezaker and Tremlett

12. *The Tate Gallery 1970-1972*, Biennial Report and Illustrated Catalogue of Acquisitions. Artist's statement on *4 Complete Clipboard Sets*, (Tate Gallery Publications, London, 1972, p.96)

13. 'Michael Craig-Martin: Interview with Anne Seymour', *The New Art*, Hayward Gallery, London, 1972, p.82

14. Fredric Jameson's, *The Prison-House of Language*, 1972, was published by Princeton University Press. Note also that Jack Burnham's *The Structure of Art* (New York, Braziller) was published in 1971.

15. In an interview with Anne Seymour published in the catalogue to *The New Art*, Craig-Martin stated: 'Underlying the Tate pieces were considerations about the natural circumstances of an exhibition there. First, the scale of the place demanded a scale different from any I'd employed before. Second, the potential for large numbers of people viewing work simultaneously. I decided to do some large things involving numbers of people. There are two things which people do naturally at an exhibition: walk around and look . . . (In my works) you're barely conscious of the fact that you're doing anything unusual at all. What I wanted was something choreographic in the sense of being controlled, but so natural and ordinary that one was barely aware of it'. ('Michael Craig-Martin: Interview with Anne Seymour', op.cit., p.82)

16. Anne Seymour, 'Commentary', *Michael Craig-Martin Selected Works 1966-1975*, Arts Council of Great Britain, 1977, n.p.

17. *The Tate Gallery 1972-1974*, Biennial Report and Illustrated Catalogue of Acquisitions, Artist's statement on *Conviction* (Tate Gallery Publications, London, 1974, p.113)

18. Reprinted in John Cage, *Silence, lectures & writings*, (1971), London 1973, pp. 109-126

19. Wittgenstein, op.cit.

20. For an incisive discussion of the impact of Samuel Beckett on Craig-Martin's art and thought ref. Anne Seymour, 'Commentary', *Michael Craig-Martin Selected Works 1966-1975*, op.cit., n.p.

21. Oscar Wilde, 'The Decay of Lying', (1889), reprinted in Oscar Wilde, *De Profundis And Other Writings,* (1954), Harmondsworth, 1984, pp.55-87. In this Wilde is proposing an art for art's sake aesthetic, one in which reality, life and nature follow art rather than the converse: 'Things are because we see them, and what we see, and how we see it, depends on the Arts that have influenced us. To look at a thing is very different from seeing a thing' (p.79). Lying is for him the best form of (aesthetic) persuasion: 'After all, what is a fine lie? Simply that which is its own evidence. If a man is sufficiently unimaginative to produce certain evidence in support of a lie, he might just as well speak the truth at once. . . Man can believe the impossible but not the improbable' (pp.59, 70). Craig-Martin stated when discussing the importance the Wilde essay had for him: 'Art is an oblique procedure. . . one doesn't get at the truth by going straight to the truth. . . one gets at the truth through a form of lying'. He then went on to argue: 'The Oak Tree. . . is clearly a lie, it depends on a lie. It also depends on co-operation in playing along with that lie in order for it to arrive at some kind of understanding about the truth'. (Unpublished Interview with Rod Stoneman, op.cit.)

22. Robert Sokolowski, 'Picturing', *The Review of Metaphysics,* 1977, pp.4,6,8

23. First published in *Artscribe,* No.14, October 1978, pp.14-15. 'Taking Things as Pictures' is reprinted in this catalogue, p.112

24. 'Las Meninas', *The Order of Things: An Archeology of the Human Sciences,* (1966), London 1977, pp.3-16

25. Sokolowski, op.cit., p.3

26. see p.112 of this catalogue

27. Norbert Lynton, 'Introduction', *Michael Craig-Martin,* Fifth Triennale, India, The British Council, New Dehli, 1982, n.p.

28. Michael Craig-Martin, Statement, October 1985, in *Entre El Objeto Y La Imagen,* op.cit., pp.231-232

29. Michael Craig-Martin, Unpublished Notes, June 1980

30. Martin Jay, 'Scopic Regimes of Modernity', in Hal Foster, *Vision and Visuality,* DIA Foundation/Bay Press, Seattle, 1988, pp.2-23. I am deeply indebted to Jay's essay for the following analysis. For a fuller discussion of the Baroque from this perspective ref. Christine Buci-Glucksmann, *La Raison baroque: de Baudelaire à Benjamin, Paris,* 1984, and *La Folie du voir: de l'ésthetique baroque,* Paris, 1986

31. In Tisdall's review, entitled 'They Know What They Like. . .', she argued, 'The retreat into the past is now in full swing'. (*The Guardian,* 1.6.1977). Richard Cork's review, 'A Charmed Circle' inveighed against what he considered the 'clannishness' of a 'cosy establishment'. (*The Guardian,* 20.7.1977)

32. Craig-Martin's closest connections and affinities are arguably with Julian Opie, one of his former students from Goldsmith's College where Craig-Martin was long an influential teacher

33. Updike quoted in Adam Gopnik, 'The Innocent', *The New Yorker,* April 10, 1989, p.113

34. ibid

35. Quoted in Anne Seymour, 'Commentary', op.cit., n.p.

36. Unpublished interview with Rod Stoneman, op.cit.

37. ibid

38. Norman Bryson, *Vision and Painting: The Logic of the Gaze,* London, 1983, 'Introduction', p. xiii

39. 50th Anniversary Gift of the Gilman Foundation Inc., The Lauder Foundation, A. Alfred Taubman, an anonymous donor, and purchase 80.32

40. Susan Sontag, 'On Roland Barthes', in Roland Barthes, *Barthes: Selected Writings,* (1982), Fontana Paperbacks, 1983, p. xxviiii

41. Max Kozloff, *Jasper Johns,* New York, 1969, p.9

42. And yet their very ordinariness and familiarity should not be underestimated in that it enshrines a distinctive philosophical position, one which Craig-Martin adumbrated recently when he stated: 'One of the most intriguing things in twentieth century art is that you can use anything to say anything: a shoe, a light bulb And if you can use them you can use anything. Objects are matter subjected to language.' (Unpublished interview with the author, September 1989)

43. Max Kozloff, op.cit., p.41

PLATES

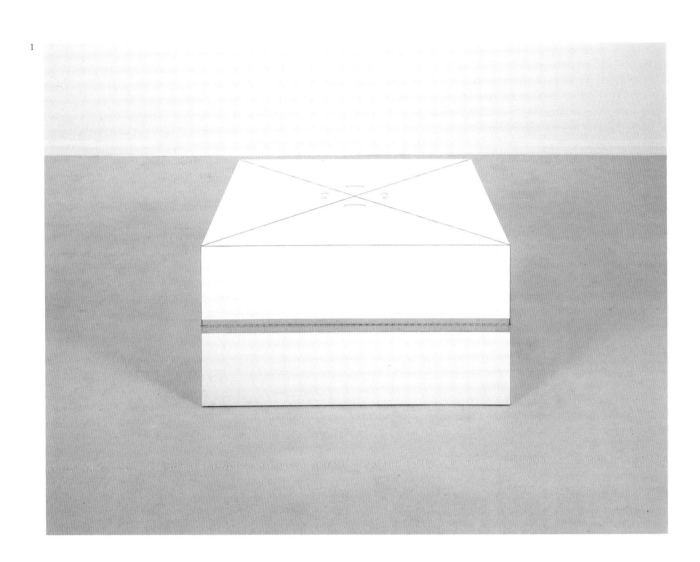

1 & 2
FORMICA BOX 1968
(remade in 1989)
Formica on plywood, 121.9 x 121.9 x 61 cms

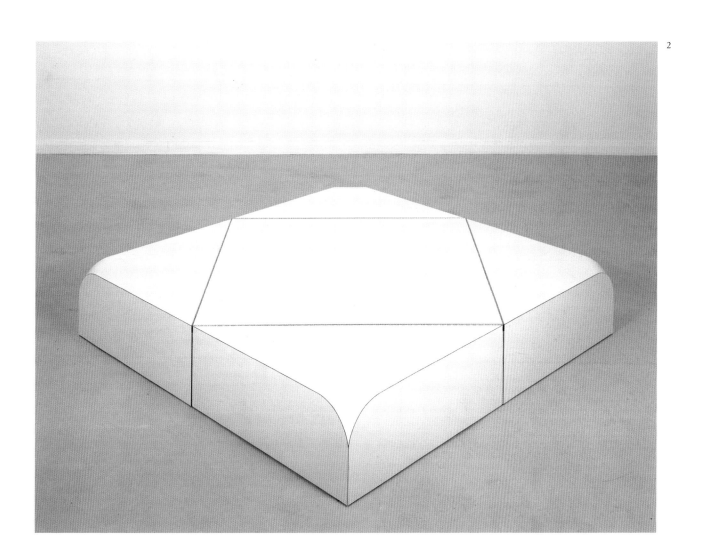

3 & 4
LONG BOX 1969
(remade in 1989)
Painted plywood, 61 x 366 x 46 cms

5

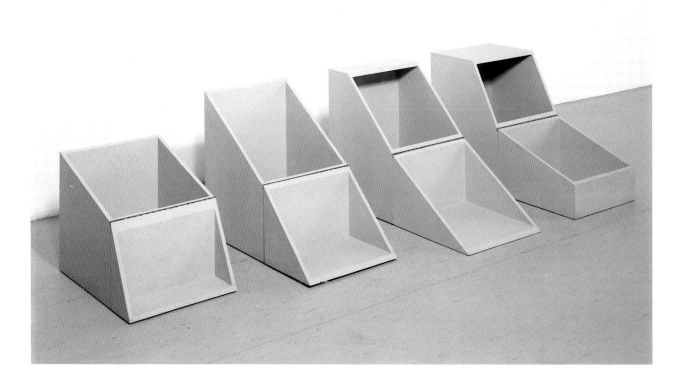

5 & 6
FOUR IDENTICAL BOXES WITH LIDS REVERSED 1969
Painted blockboard, 61 x 244 x 91 cms

(overleaf)
7
PROGRESSION OF FIVE BOXES WITH LIDS REVERSED 1969
(remade in 1989), plywood coated with clear sealer, 61 x 411.5 x 76.2 cms

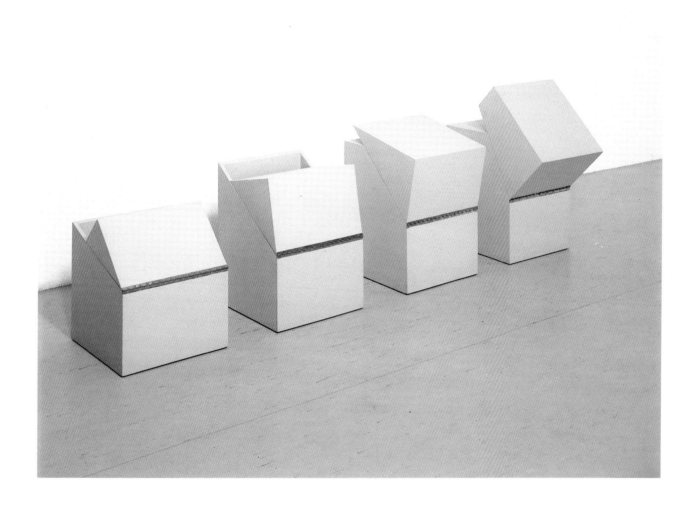

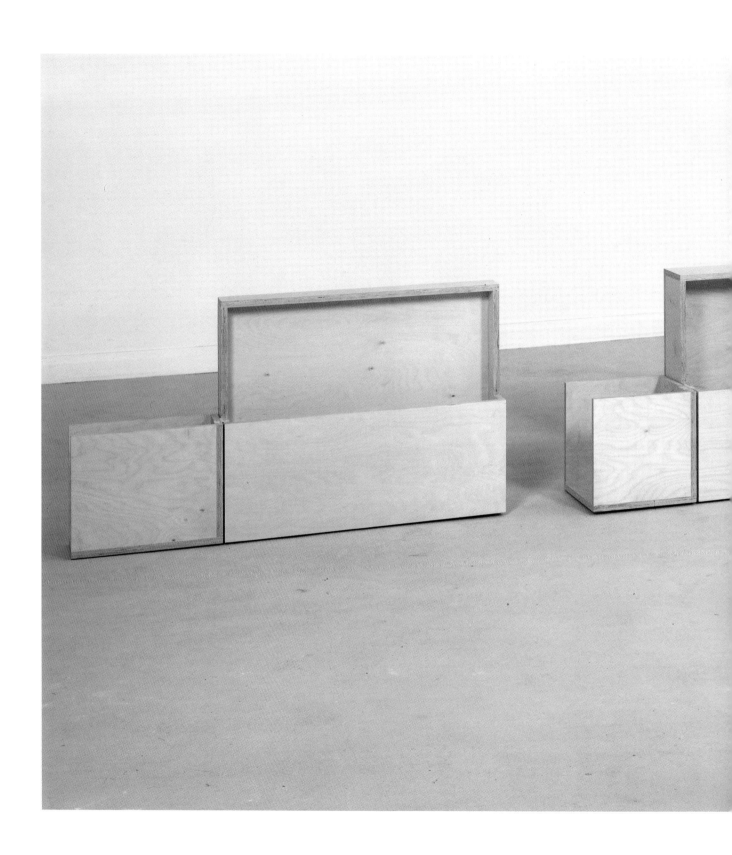

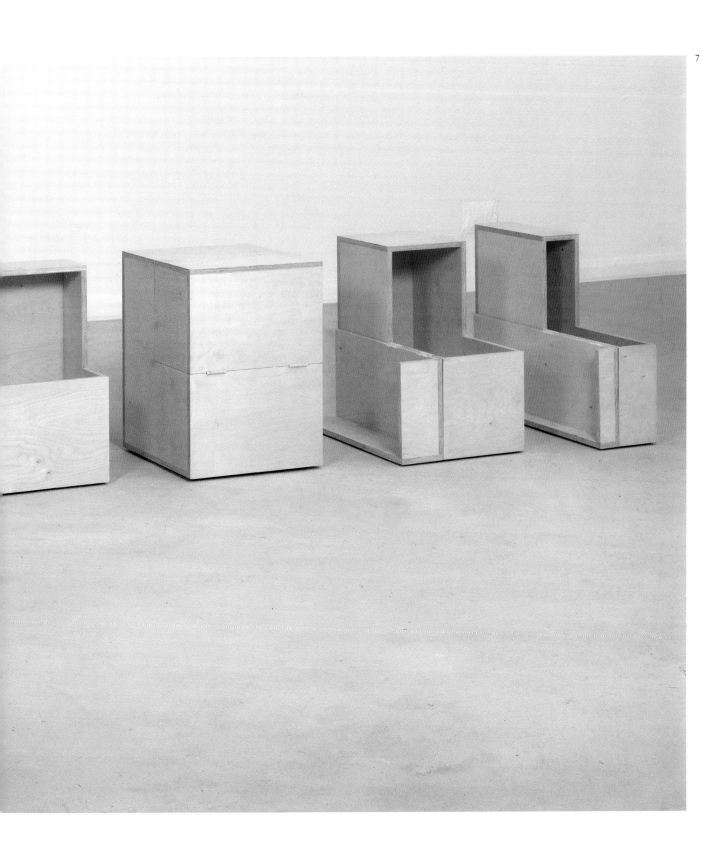

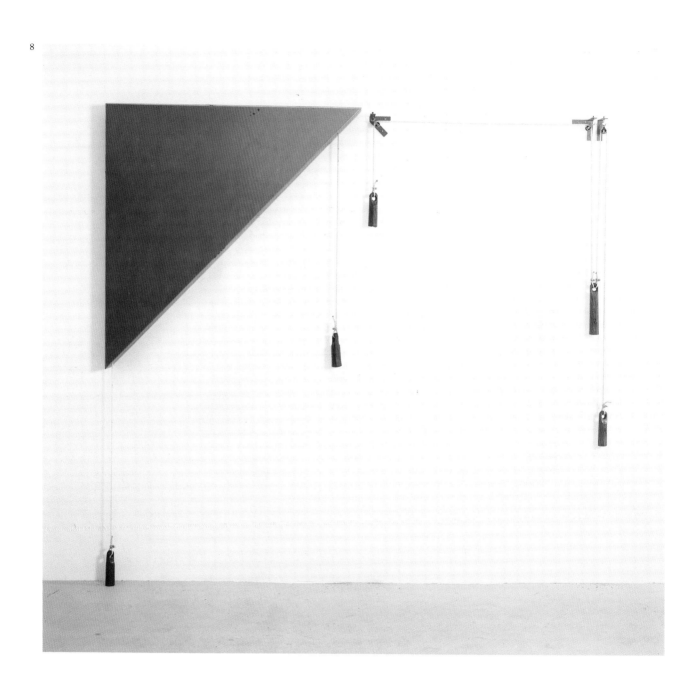

8

COUNTER-WEIGHT ENCLOSED AND EXPOSED 1970
(remade in 1989)
Lead, nylon rope and mild steel, 963 x 963 x 8.8 cms

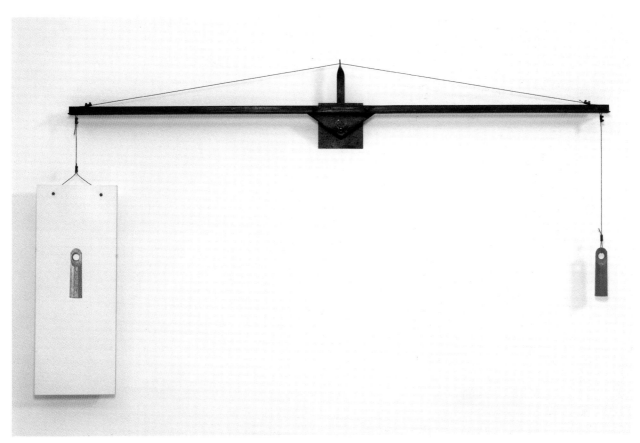

9

SIX FOOT BALANCE WITH FOUR POUNDS OF PAPER 1970
Mild steel, paper (lithographic image) and lead, 109.5 x 195.3 x 8.8 cms

(overleaf)

10

EIGHT FOOT BALANCE WITH TWO REINFORCED PLYWOOD SHEETS 1970
(remade in 1989)
Wood and mild steel, 183 x 488 x 244 cms

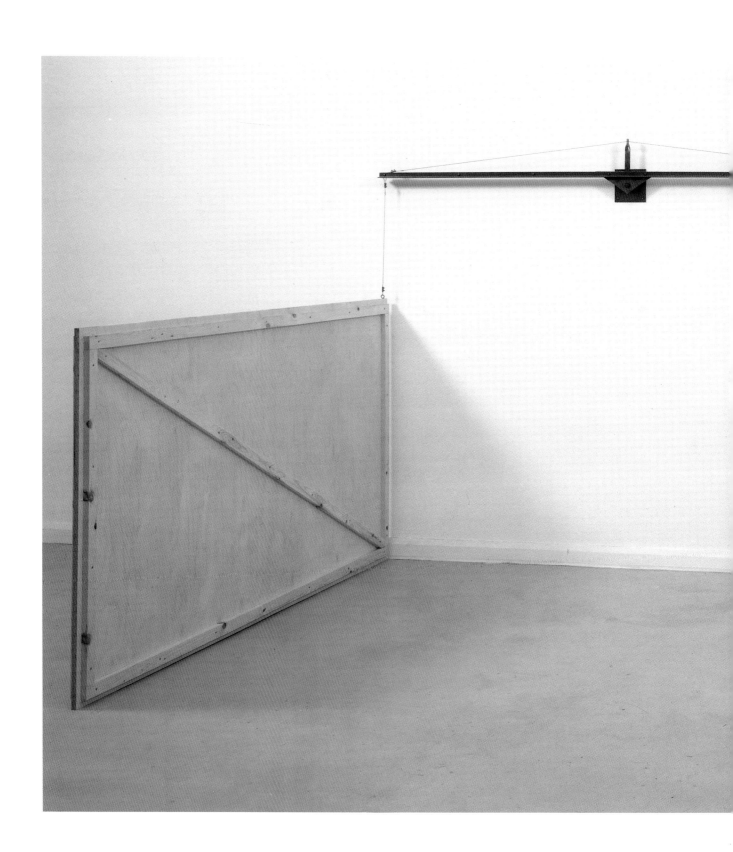

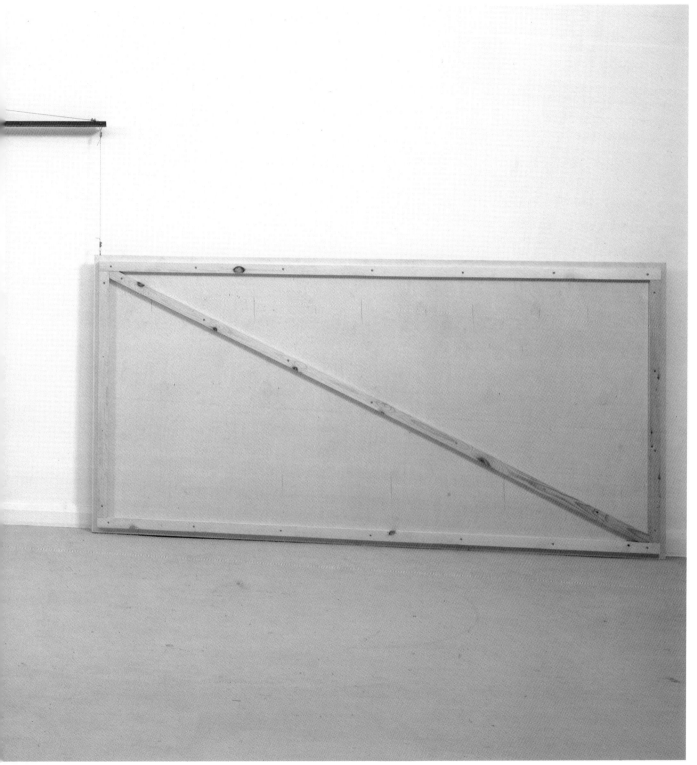

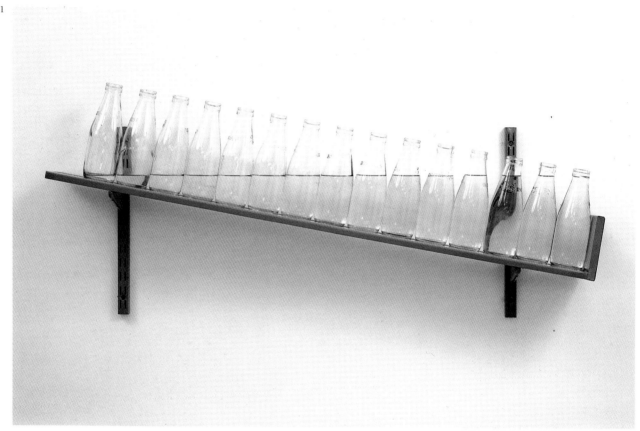

11
ON THE SHELF 1970
Objects and water, 51 x 109 x 15 cms

12
ON THE TABLE 1970
Objects and water, 122 cms. square, variable height

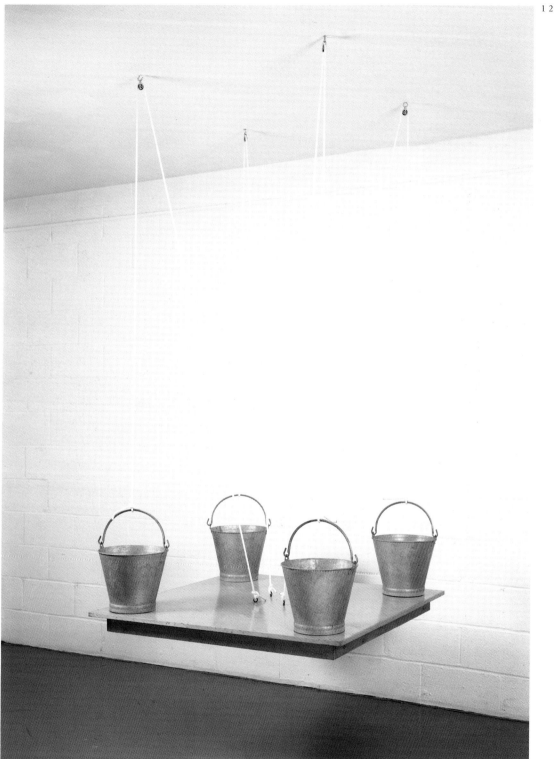

13

FOUR COMPLETE SHELF SETS . . .
EXTENDED TO FIVE INCOMPLETE SETS 1971
(partially remade in 1989), assorted objects, 210.8 x 33 x 15.2 cms

(overleaf)

14

ASSIMILATION 1971
Assorted objects, 7.92 metres long

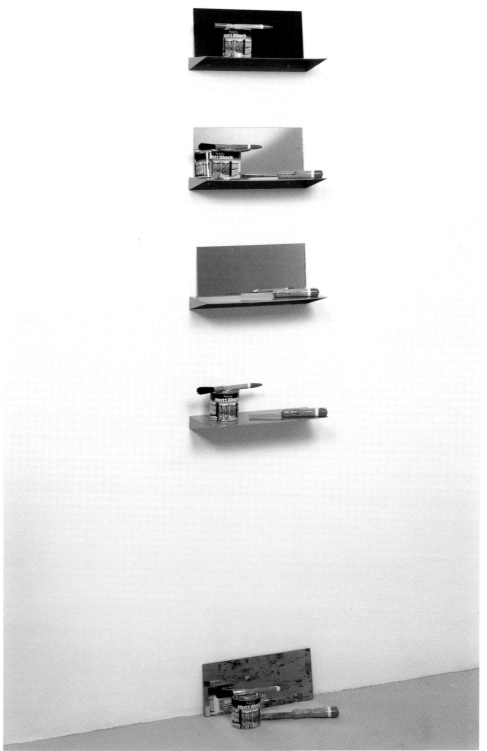

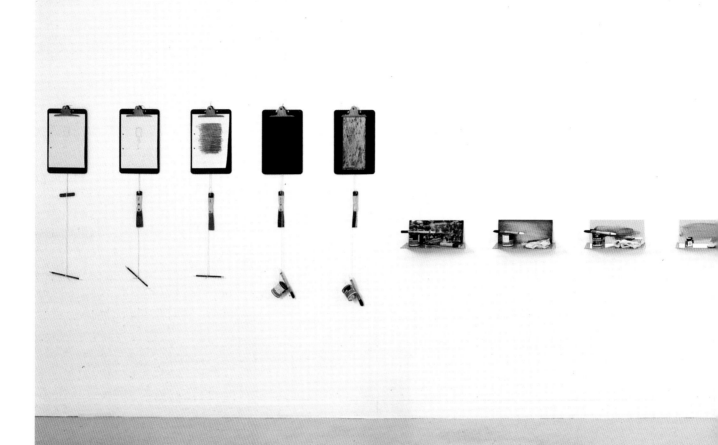

15 & 16

FORWARDS AND REVERSE 1972

(remade in 1989)

Paint on mirrors, metal brackets, 134.1 x 188.9 x 12.7 cms

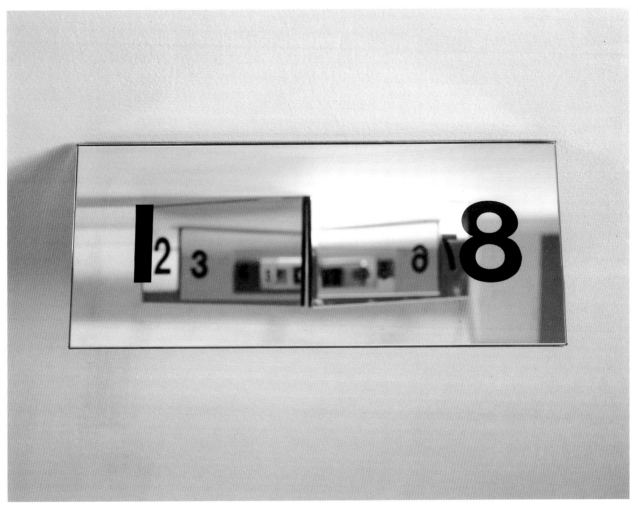

I have an idea of what I am like.

I have a different idea of how I appear to others.

Part of how I appear I intend.

Part of how I appear I do not intend.

Part of how I appear I recognize.

Part of how I appear I do not recognize.

Others have a different idea of what I am like.

Part of what I intend others miss.

Part of what I don't intend others see.

Part of what I recognize others see.

Part of what I don't recognize others see.

17

SOCIETY 1973

Mirror, tape and handwriting on wall, 11 units, each 53.3 x 38.1 cms.

Q: To begin with, could you describe this work?

A: Yes, of course. What I've done is change a glass of water into a full-grown oak tree without altering the accidents of the glass of water.

Q: The accidents?

A: Yes. The colour, feel, weight, size . . .

Q: Do you mean that the glass of water is a symbol of an oak tree?

A: No. It's not a symbol. I've changed the physical substance of the glass of water into that of an oak tree.

Q: It looks like a glass of water . . .

A: Of course it does. I didn't change its appearance. But it's not a glass of water. It's an oak tree.

Q: Can you prove what you claim to have done?

A: Well, yes and no. I claim to have maintained the physical form of the glass of water and, as you can see, I have. However, as one normally looks for evidence of physical change in terms of altered form, no such proof exists.

Q: Haven't you simply called this glass of water an oak tree?

A: Absolutely not. It is not a glass of water any more. I have changed its actual substance. It would no longer be accurate to call it a glass of water. One could call it anything one wished but that would not alter the fact that it is an oak tree.

Q: Isn't this just a case of the emperor's new clothes?

A: No. With the emperor's new clothes people claimed to see something which wasn't there because they felt they should. I would be very surprised if anyone told me they saw an oak tree.

Q: Was it difficult to effect the change?

A: No effort at all. But it took me years of work before I realized I could do it.

Q: When precisely did the glass of water become an oak tree?

A: When I put water in the glass.

Q: Does this happen every time you fill a glass with water?

A: No, of course not. Only when I intend to change it into an oak tree.

Q: Then intention causes the change?

A: I would say it precipitates the change.

Q: You don't know how you do it?

A: It contradicts what I feel I know about cause and effect.

Q: It seems to me you're claiming to have worked a miracle. Isn't that the case?

A: I'm flattered that you think so.

Q: But aren't you the only person who can do something like this?

A: How could I know?

Q: Could you teach others to do it?

A: No. It's not something one can teach.

Q: Do you consider that changing the glass of water into an oak tree constitutes an artwork?

A: Yes.

Q: What precisely is the artwork? The glass of water?

A: There is no glass of water any more.

Q: The process of change?

A: There is no process involved in the change.

Q: The oak tree?

A: Yes. The oak tree.

Q: But the oak tree only exists in the mind.

A: No. The actual oak tree is physically present but in the form of the glass of water. As the glass of water was a particular glass of water, the oak tree is also particular. To conceive the category 'oak tree' or to picture a particular oak tree is not to understand and experience what appears to be a glass of water as an oak tree. Just as it is imperceivable, it is also inconceivable.

Q: Did the particular oak tree exist somewhere else before it took the form of the glass of water?

A: No. This particular oak tree did not exist previously. I should also point out that it does not and will not ever have any other form but that of a glass of water.

Q: How long will it continue to be an oak tree?

A: Until I change it.

AN OAK TREE 1973
Objects, water and printed text, 13 cms. high

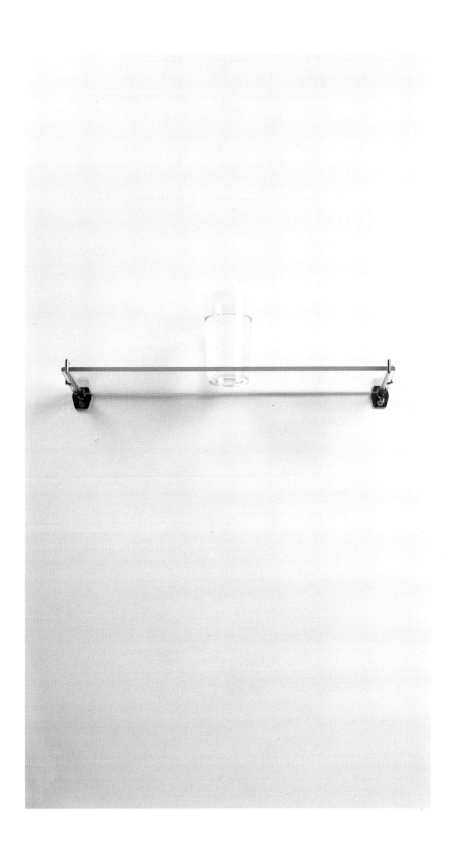

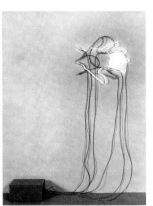

19
SLEIGHT-OF-HAND 1975
Neon, 57 x 63.5 x 5 cms

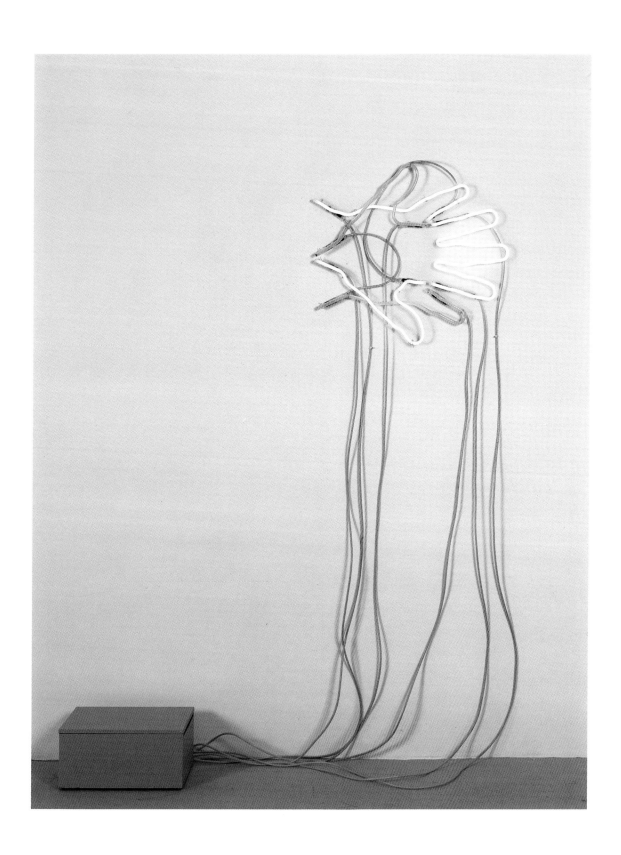

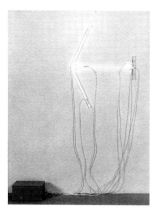 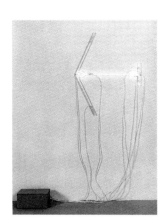

20

A SHORT FILM FOR ZENO 1975

Neon, 110 x 84 x 5 cms

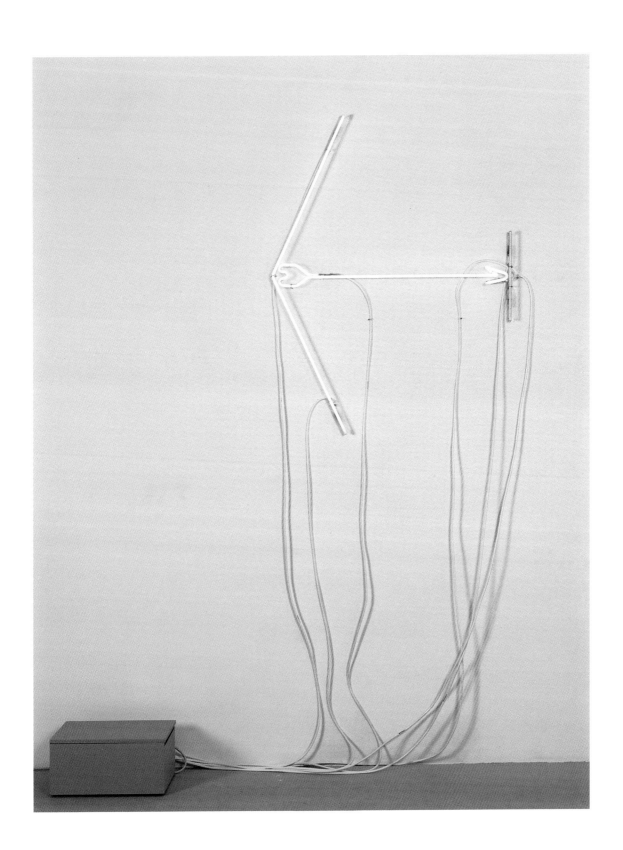

21
PACING 1975
Neon, 76 x 67 x 5 cms

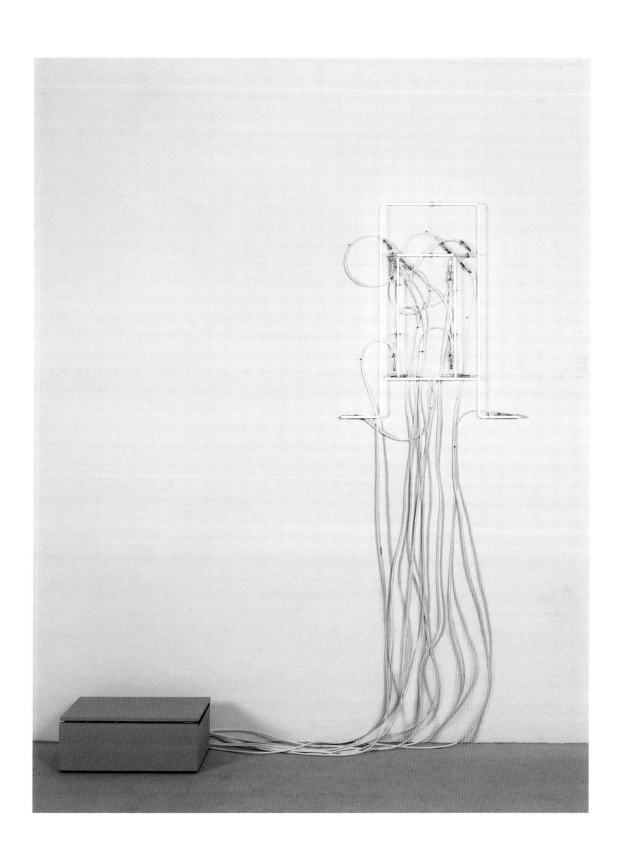

A MID-ATLANTIC CONVERSATION

ROBERT ROSENBLUM

The following interview took place in London this summer between the American writer and art critic, Robert Rosenblum, and Michael Craig-Martin. Robert Rosenblum is Professor of Fine Arts at New York University.

As a New Yorker who spends a lot of time in London and who also travels a lot, I'm particularly interested in the whole question of art and nationality, of local flavour and local colour. You seem to me to represent one of the most fascinating examples of mid-Atlantic or Anglo-American art with your mixed background – born in Dublin, studied in America, living in London. I'd be very glad, Michael, to hear your own thoughts about where you belong, on which side of the Atlantic, or is it somewhere in the middle?

I think my situation is peculiarly my own. When I first came to London from America I had naive ideas about the nature of internationalism in art, and although I still believe in internationalism, I didn't really understand the role of national values then, national traditions, national attitudes. Living here for over 20 years, I'm very much more conscious of the things that make British culture special and unique, the ways in which I'm not British and the fact that my values and attitudes were formed in America by early experiences and education. They don't go away. My work may not be archetypally American, but I certainly don't think it looks typically British.

Well, how would you compare your situation, for instance, to that of Kitaj, or Jim Dine, Americans who seem to live here most of the time?

Most American artists who have spent a lot of time in Britain tend to have done so because they're Anglophiles, because they were drawn by certain aspects of British culture. I never was an Anglophile and in many ways I'm still not. I came to England originally partly because of a sense of family connection with London. Although I was born in Ireland, my parents lived in London during the war and I was always haunted by the feeling that except for a quirk of circumstance

I probably would have grown up in London. I always had a curiosity about what it would have been like to live here. I looked for an art school teaching job in England at the suggestion of Victor Burgin whom I knew at Yale. When I came to England in 1966, I felt at ease very quickly, I met people I liked right away – people who are still close friends. I didn't come to Britain in mid-career as an artist, but straight from art school. I needed a teaching job so that I could make a living and my own work. It was through teaching that I met people and found my way into the British art world. Ironically I could never have become as fully integrated here as an artist if I had been able to spend all my time in the studio. I only intended to stay for a year, but frankly I was trapped by poverty in the beginning: I made too little money to afford the air ticket back. After a couple of years, opportunities arose to show my work that made it seem foolish to leave, at least until these opportunities had been realised. One thing led to another; a chain of events occurred in which I came to stay and make my life here.

Well, I guess one way in which one can determine the national allegiance of your art concerns the way outsiders see it. You've exhibited in a lot of places, from Poland to Canada to Australia. Do they see your art as American or British, or universal, or none of these?

As my career as an artist has taken place almost entirely in Britain, my work has always been shown internationally as British, and I assume that's how people think of it. As an artist, I have never been treated as a foreigner here. When I hear a recording of my still American accent, it amazes me how rarely anyone even indicates that I'm not British.

Well, beginning with the '60s and continuing through 1989, it looks

as if you follow the broad patterns of the development of American art quite closely, from Pop Art and Minimalism into Conceptualism, into what I would even think of as a kind of neo-Pop situation in the late 1980s, mixing them together in an amalgam that recalls New York, I keep asking myself about national inflections, that is, would your art have looked the same had you done it in New York? I keep trying to piece out those components which look American and those which seem to have a British inflection. You've exhibited with British artists here in a number of group shows. Which ones do you feel the closest kinship with?

Well, I was becoming established as an artist and my work was becoming known during the initial period of Conceptual Art. The artists I was loosely grouped with were Barry Flanagan, Richard Long, Gilbert & George, Victor Burgin – the artists in *The New Art* exhibition at the Hayward in 1972. Although there were important differences between what I did and what they did, I always admired their work and felt a sense of basic kinship of attitude. The differences were partly to do with generation. Though there was little difference in age, I left art school a few years earlier than they did. I'm slightly mid-generation as well as being mid-Atlantic. Victor Burgin was the only one with direct experience of recent American art, and his work had come directly through Minimalism. The others had all been to St. Martin's at roughly the same time and shared this common background. I also admired the work of a number of artists who had studied at Newcastle when Richard Hamilton taught there – Mark Lancaster, Tim Head, Stephen Buckley, Rita Donagh, Tony Carter. Through Richard and his connections with American Pop artists, they were very well informed about American art. There are also artists whose work has emerged in the '80's like Bill Woodrow, Richard Wentworth, Julian Opie and Lisa Milroy with whom I feel an affinity. My attitude towards art, however, is essentially a conceptual attitude, formed in the late '60s and early '70s and this is not the same for these younger artists. But many of the things they are interested in, particularly their interest in objects, I share in a way that I didn't with artists who were principally involved with land-scape, natural materials or photography.

Well, one of the things I find so distinctive about your art, and this may have something to do with a mid-Atlantic position, is that it's really hard to pigeon-hole it into any of the familiar categories, Pop or Minimal or Conceptual. It really seems to be a grand synthesis of various American points of view. So that, on the one hand, a lot of your work would look completely at home with an exhibition of Minimalists from the '60s and '70s but, on the other, the cerebral component of your work would be equally at home with the '70s Conceptualists. And the theme of Pop Art, in so far as you are fascinated with the look of manufactured objects, often translated into linear diagrams, is again a continuing motif without which your work couldn't perhaps exist.

I'm very struck by what you've said. In a way it does describe what has been my position here, of being an observer of American art, which I always feel I understand quite naturally, but as I'm not there, I'm not really a participant. American art has always been my basic reference, but I've worked in a British context. What you identify as the Americanism of my work is clearly true – like my accent I've never lost it – but I know that if I hadn't lived in Britain my work would have been fundamentally different. I feel as much an outsider there now as I do here.

This raises questions about the pedigree of your work, its ancestry in the '60s. It seems to me that you could be understood either in terms of the Minimalism of Don Judd or in terms of the Pop Minimalism of artists like Andy Warhol. How do you feel about this lineage? I mean do you pay allegiance to both Judd and Warhol, and related artists, are you a mixture or ?

I certainly would pay allegiance to both those artists. I was a student during the period when Warhol's well-known Pop work was first shown, and I saw most of the original exhibitions. They obviously had an enormous impact on me. I believe that, though not alone, Warhol is possibly the most important figure in the fundamental change that occurred in art in the early '60s, and that this marked the beginning of

truly post-war art, truly American art. The Abstract Expressionists look increasingly European, a kind of culmination of the great European tradition. An artist like Warhol seems to me to have very little to do with that. Warhol changes the whole notion about what a work of art is and how one deals with it. Obviously there were antecedents for this change, but it's as though the things that Duchamp, and others like Picabia, implied as possible took a very long time to find their place in the world of artists in general. For me all the really critical developments in art in the '60s – Pop, Minimalism, Conceptualism – derive from the same fundamental premises and attitudes.

Well, it's fascinating to think that, in terms of Warhol's innovations, even in 3-dimensions, such things as the Brillo boxes are, like your works, strange hybrids, in that they are simultaneously objects we're familiar with and completely cerebral. Just on those foundations alone you're part of that tradition. This also brings in the whole question of this hybrid character which began also in the '60s, of art that seems to be simultaneously furniture, or at least to have 3-dimensional presence in interiors, and abstract or Minimal art. I'm thinking of people like Artschwager or, somewhat later in the '70s, Scott Burton, who make you uncertain whether you're looking at sculpture or furniture, or both. This seems also to be related to your wish to destroy conventional boundaries and to focus attention on ordinary things as extraordinary things: having object character or abstract character at the same time as being ordinary and real. How do you feel about this kind of furniture/sculpture fusion or, in your case, Venetian-blinds that seem to function simultaneously as flat paintings?

I grew up with the idea of wanting to be a radical artist, whatever that might have meant. The art I loved had all been thought radical in its time. The only way to get a sense of what art might be – which is what I mean by radical – is to go to art's apparent boundaries. To me the most interesting things in art happen in the border area between art and non-art, between sculpture and furniture, between one form of art and another, between painting and sculpture.

That's why, among other things, I think I find your new paintings so tonic, because they don't look like paintings, they somehow look like Michael Craig-Martin's ideas of paint on a rectangular canvas with an object represented on them – they seem to come out of a wholly different tradition from the accepted one of easel painting. You've managed to revitalise the very old-fashioned idea of painting.

I was curious, Michael, about the relationship of your work to abstract art because it occurred to me that, even though your work in terms of the visual seems to belong very much to a tradition of pure Minimal painting, and sculpture of an abstract character, it is also inconceivable as pure abstract art because it always deals with either an object or an idea of an object, or the idea of a work of art. There is always some other component that is complicating it, removing it from an ivory tower of abstraction into something to do with ideas and things in the real world. What is your own feeling about your relationship to abstract art?

There's a sense in which I think of myself as an abstract artist, that everything I've done is abstract, certainly much more related to abstraction than my idea of how people normally think of representation. I've tried to reconcile certain aspects of abstraction and representation that are usually considered irreconcilable. The clearest way to see this is that what I value in my work, what interests me most, is direct experience, the direct experience of the viewer at the moment of viewing. When I make a picture, it does not refer to a situation which occurred previously or elsewhere. I'm not showing you a landscape that you cannot see, that I saw, that you haven't seen. In my work what you get to see is what I got to see: nothing precedes it. This is a notion that comes from abstraction, whether one's looking at a Jackson Pollock or a Carl Andre; the experience that you have as the viewer, at the moment of viewing, *that* is the experience of the work of art.

So it's not second degree, it's immediate.

Exactly.

Well, as I see it, you have crossed so many territories, and fused them

in quite a miraculous way, that your work can fit into many kinds of systems, but each system would only partially cover it. I'm interested, however, in the idea of your finally being an abstract artist, even though there is always the component of objects and the demonstration of an idea. After all, the bottom line is the visuals, and your work looks very much of a piece. You have your own lean, cool and elegant style, and it's always there, whether it's in 3-dimensional or 2-dimensional form. That, after all, is the final coherence of an artist, that the works really look alike and exist in terms of their own visual universe – and this continuity has been sustained in your work through two decades. I'm interested too in speaking of the synthetic aspects of your work in relation to the question of painting versus sculpture, because it would be hard to pigeon-hole you in either category.

What is your own position about that question of medium? Are you painter, sculptor, or none of these, a, b, or c?

I think I should be called an artist, rather than a painter or sculptor, though I am often referred to as a sculptor. I don't think I've ever really made sculpture, though I've done many things that are 3-dimensional, and I've done things which are just like paintings, but it would be a mistake to think of them strictly in terms of painting. I've always found the divisions between things to be arbitrary, artificial and stultifying. I feel overwhelmingly resistant when a social convention is treated like a natural or God-given law. I once heard Buckminster Fuller say in a lecture that the most important ideas were not those that excluded the most but those that included the most. I've tried to find ways of being inclusive. I've tried to bring the sensibility of one thing to bear on another. To be honest I've always considered what I think of as the painter's sensibility to be more interesting than what I consider to be the sculptor's. A great many artists I feel kinship with started as painters, left painting at a certain stage, and started making objects. It pleases me that my work in this exhibition ends with my most recent work which is painting. I started studying art as a painter, and here we are again with paintings, my whole career coming full circle.

Well, it's fascinating to realise that it would be impossible to predict, say, what your next show would be composed of, whether it would be tapes on walls, metal armatures, machine-made objects, or paint on canvas, or some mixture of all of these. I'm fascinated too by your attitude towards objects. I mean there's been a lot of talk in the last decades about the new conception of the commonplace object, whether in terms of the Pop artist of the '60s or later Conceptual approaches, say that of Joseph Kosuth demonstrating what a chair might mean. I'd be interested to hear your thoughts about what objects mean to you, how you choose them, how you prefer to see them reproduced.

I think I have a complicated notion about what objects, ordinary objects, are. I think of ordinary objects as representing some kind of perfect sculptures. It's as though an ordinary object can have all the characteristics I would like a sculpture to have, although of course it is not a sculpture. It has to do with the way a thing is organised, the way it holds its meaning, the way it expresses itself as itself, that fascinates me: the way a pile of wood can be organised into a table, the way the concept 'table' holds the bits of wood together as surely as glue or nails. I love the idea that there are things which are universally known, universally understood, and that they are totally man-made, completely part of the artifice of our creation.

Do you ever use objects from nature?

Virtually never. Even in the drawings, I only draw man-made objects.

Do you reproduce these objects from existing drawings or do you draw in the manner of a commercial or a diagrammatic illustration?

All of the drawings are of actual objects which I draw free-hand from life and then trace in a tape-line on clear acetate. This line generalises the object, gives it the diagrammatic quality you refer to. It also gives a unity to the character of the line itself, so that the line, in a sense, drops away. I want my pictures of objects to look as much like unadulterated facts as the objects themselves.

The objects that you include in your art are, as I see them, completely cerebral. In the most literal sense they have no weight, no mass, and their ideas as objects can even overlap and intersect as if they were ghosts. It's most fascinating that they can exist that way in every medium, but in all media they are completely immaterial, they are ideas of objects. I'm curious just thinking abuot the choice of objects, when you have, as it were, a composite still life, as in some of the wall tapings. Is there ever any underlying sense or allegory in the particular selection, the grouping, of objects, like those old fashioned allegorical still lifes in which objects might represent music, or trophies and dead animals might represent hunting? Is there some meaning in the selection?

Occasionally I have played with such notions. I have tried to use the same individual images in as many different configurations, creating as many different relationships as I could think of. Sometimes the images are obviously disengaged from each other, at others they imply an ordinary still life, or an allegory, or a Surrealist configuration. But I'm not really interested in Surrealism or allegories: I want to make those structures of meaning transparent. I try to get rid of as much meaning as I can. People's need to find meanings, to create associations, renders this impossible. Meaning is both persistent and unstable.

Well, they do look as though they are existing in Plato's cave of ideas. There's the archetypal safety pin, archetypal flash light or light bulb, and these objects make you see them as you've never seen them before. They exist in a kind of pure idea of, to use a Germanism, 'objecthood'. I'm curious also about the drawing style of these objects as a rich tradition to which you belong of reproducing objects as a commercial illustrator might reproduce them, and sometimes it seems to me that they even have an American versus British inflection. I'm thinking particularly of the way, say, that when Lichtenstein in the '60s reproduces a disembodied object, it looks very different from the way that Patrick Caulfied, for instance, would do it, apart even from the fact that you actually seem to have a kind of bi-national choice of objects. I remember in your work both electric bulbs with screw-on tops as well as electric bulbs with prongs. The drawing style

seems also to hover in between the look of British objects and American objects. Do you know what I'm talking about?

Yes, I think so. To me the most obvious characteristic of American art is that of directness, the idea that directness is the prerequisite of quality. I remember as a student a tutor used to say 'simple and direct, follow your traditions, simple and direct'. That is not a British notion. The British are determinedly indirect, nothing is ever approached directly; most things have a socially coded meaning which is never explained or even overtly referred to; you are expected to know. If you don't already know, you're probably not meant to. On the other hand the British also have a highly developed idea of common sense: no nonsense; the obvious; simply the way things are. I tried to draw the objects as directly and 'commonsensically' as possible. If you take the most ordinary light bulb, one of the characteristics of such an object is that you don't notice its design, you just forget it. It's the other light bulbs that look designed. The one that embodies one's idea of 'light bulb' gives no sense of being designed at all. I was trying to find a way of drawing that was equivalent to that notion of not designed, of how things look before anyone gets around to drawing them.

But it's rather interesting that, almost literally, the distinction between direct and indirect might characterise the way objects look in American, as opposed to British, Pop traditions, since it seems to me that most of your objects are rendered from a slightly oblique angle, whereas an artist like, say, Lichtenstein or Warhol would show them absolutely head on, like an assault to the eye. Maybe this is a British inflection for objects are usually seen from a polite angle, if we may say that! On the other hand, just thinking again of this persistent theme of British versus American, the scale of your work often seems to me to have that over-sized, bill-board quality that one associates particularly with American scale whether it be in abstract art or in Pop Art like that of Rosenquist, and this seems particularly clear in some of your wall drawings. What is your sense of scale, British versus American, and how does it affect your work?

My sense of scale is based on life-size – body size. Going back 7 3

to real objects, a milk bottle is a certain size – they're all more or less the same – and that's life-size, real size, and although a milk bottle is comparatively small, it tells me my size because of it's size. On the other hand, if I make a drawing of a milk bottle, it can be any size and still retain the fact that it is a drawing of a milk bottle. Images don't have a 'normal' size. For an image to have the same presence as a real milk bottle, it often means having to make it bigger. It seems to me that there needs to be some way in image making of compensating for the loss of physicality and potency that exists in the real world, and one of the ways of doing this is by increasing the scale. For an image of a milk bottle, life-size may mean the size of my whole body. Does that make sense?

Yes, because you know suddenly that these drawn objects loom large and make you feel that you've never seen a grand piano, a metronome or a fork in the form of an idea. They seem attuned to public scale and to intellectual scale, if you will, rather than to actual utilitarian scale. Looking at your most recent works – I'm thinking in particular of the paintings with monochrome ground and just one diagrammatically drawn object – I was struck by the fact that they had a flavour I've often discerned in the art of the mid to late '80s namely that of a kind of historical revival, a 'neo' character. They almost look to me as though they were meditations on the first discoveries of Pop and Minimalism in the '60s, a kind of re-cycling in a nostalgic manner. I'm wondering if you feel this way about it, or if there's any revival aspect to your work now, as there is in the work of so many other artists?

I hate the notion of nostalgia in art but I must say that over the past few years I have been struck each time I have seen a great work of the '60s again by how beautiful, rigorous and radical they still look. Also I feel that my own work has always been an attempt to create a world in which it became permissible for me to include as many things as possible. That's one of the reasons why my work has taken so many forms over the years. Each thing one does makes certain things more possible. I've wanted to make paintings for a long time, I've worked with pictorial imagery for more than

ten years without making a painting. There's nothing about the paintings that couldn't have been done by me quite a long time ago, but I didn't do them before because I couldn't.

Well, maybe this is just part of getting older. After all you have a two-decade retrospective right now, and it makes you think backwards as well as forwards, so it is perhaps a kind of Proustian experience for you in terms of where you started, of your origins. How do you feel about the future? This is the perfect point, 1989, to look not only back to two decades of work, but to look forward to the next two. Do you have any new plans, any new directions?

Preparing for this exhibition has been an unexpectedly strange experience for me. The most unnerving thing has involved the re-making of many early works. There was a fire in 1975 at the studios where I stored my work and I lost everything I had made prior to that date. The re-making of these pieces has been like reliving my whole career telescoped into a few months. It has put me directly and simultaneously in touch with the whole range of my work – objects, wall drawings, paintings. In the past I have usually found that for me to do one kind of work has required abandoning the previous kind. For the first time I feel able to move freely through the whole range of the languages I have opened up for myself.

Well I must say that it's a tribute to your achievement of totally breaking the boundaries of painting and sculpture, objects and abstraction, that your rectangular paintings look as though they're not paintings in any conventional sense, but objects by Michael Craig-Martin that happen to be, just at this particular moment and in this series, paint on canvas. Who knows what might happen next?

PLATES

22

UNTITLED PAINTING NO. 4 1976
Oil on canvas, 183 x 183 cms

(overleaf)

23

UNTITLED PAINTING NO. 2 1976
Oil on canvas, 122 x 122 cms

24

UNTITLED PAINTING NO. 1 1976
Oil on canvas, 122 x 122 cms

25

HAMMER, SANDAL, SARDINE TIN 1978
Tape on wall, variable dimensions

(overleaf)

26

UNTITLED WALL DRAWING 1979
Tape on wall, variable dimensions

27

MODERN DANCE 1981
Tape on wall, variable dimensions

28

READING (WITH GLOBE) 1980
Tape on wall, variable dimensions

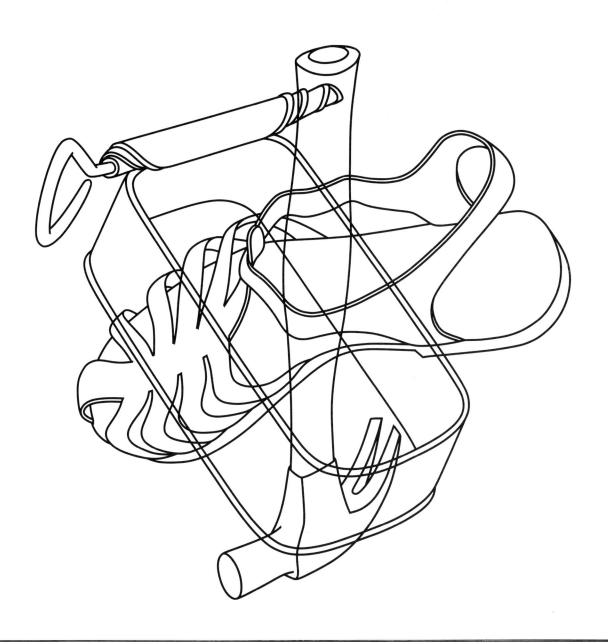

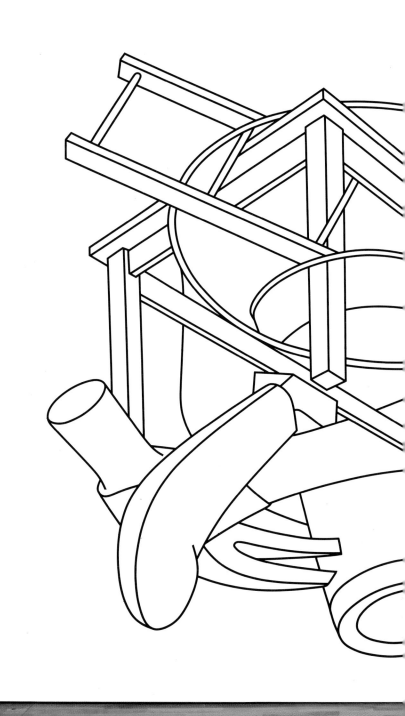

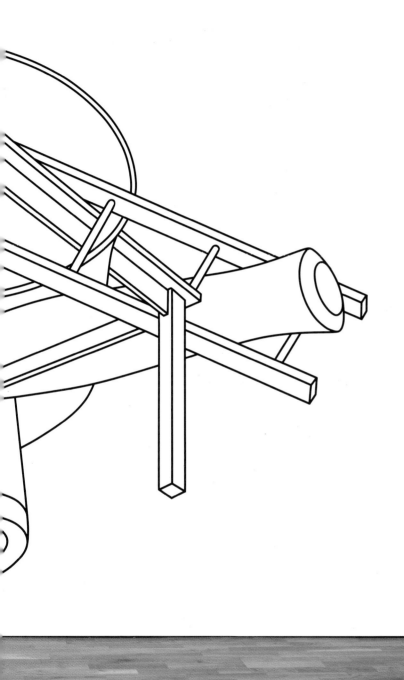

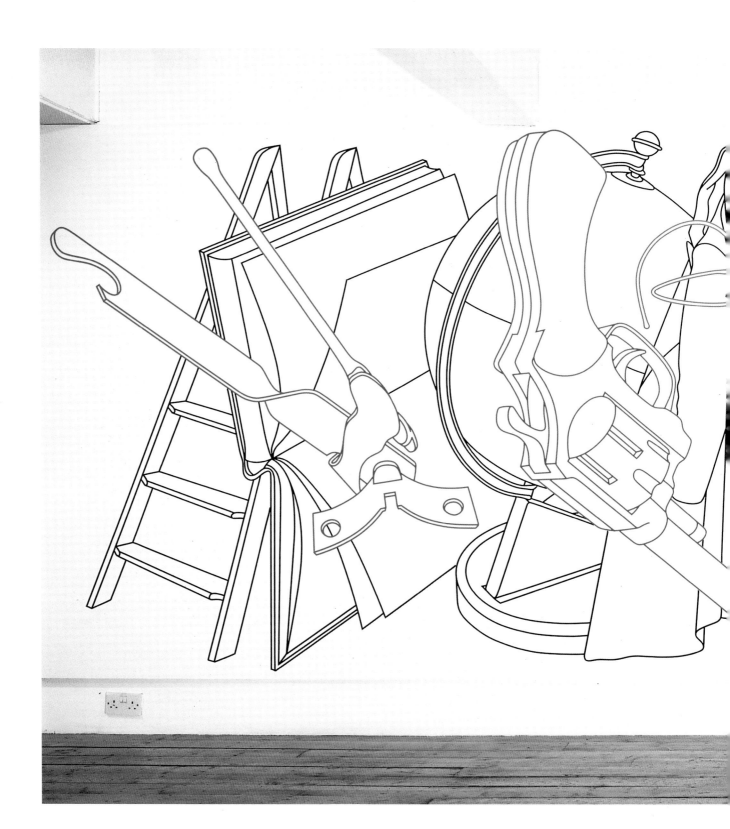

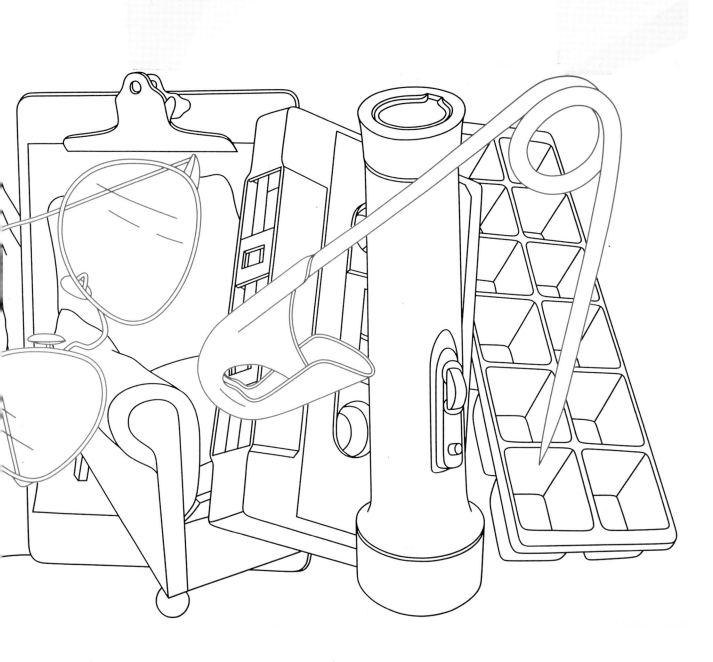

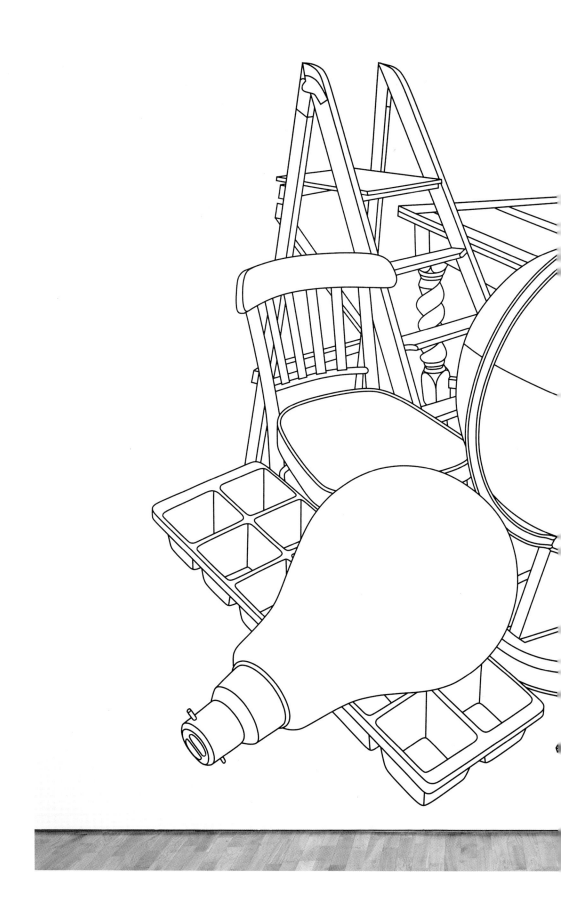

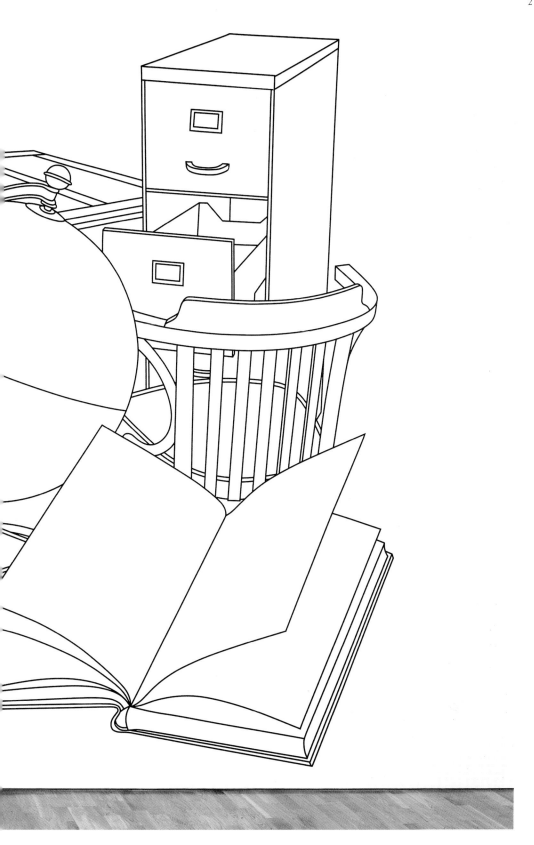

29

MAN 1984

Oil on aluminium panels with painted steel rods, 233.7 x 132 x 30.5 cms

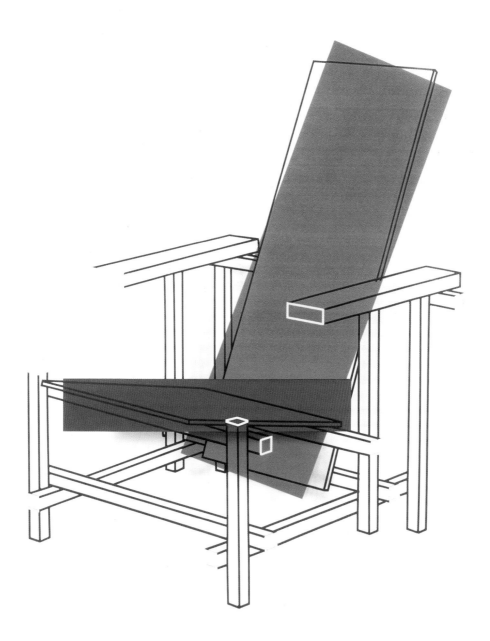

THE THINKER 1985
Oil on aluminium panels with painted steel rods, 184.4 x 144.8 x 22.9 cms

31

METRONOME 1985

Oil on aluminium panels with painted steel rods, 96.5 x 137 x 17.7 cms

33

GLOBE 1986

Oil on wood with painted steel rods, 82.5 x 52 x 53.4 cms

(previous page)

32

SIDE-STEP 1987

Aluminium and painted steel rods with aluminium ladder, 183 x 68.6 x 10.2 cms

34

STILL LIFE WITH INTERIOR 1987
Aluminium, painted steel rods and perspex light box, 247 x 214 x 25.4 cms

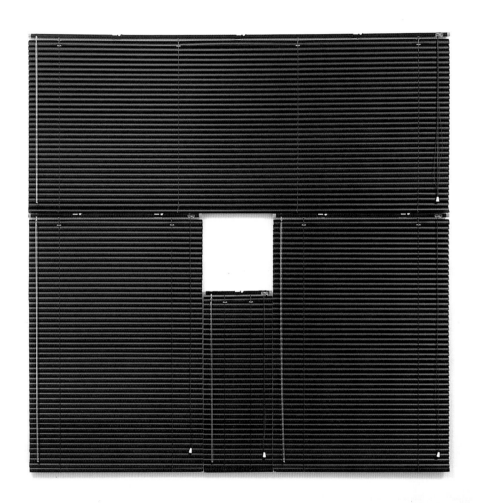

35
UNTITLED (BLACK) 1989
Venetian-blind, 183 x 183 x 3.2 cms

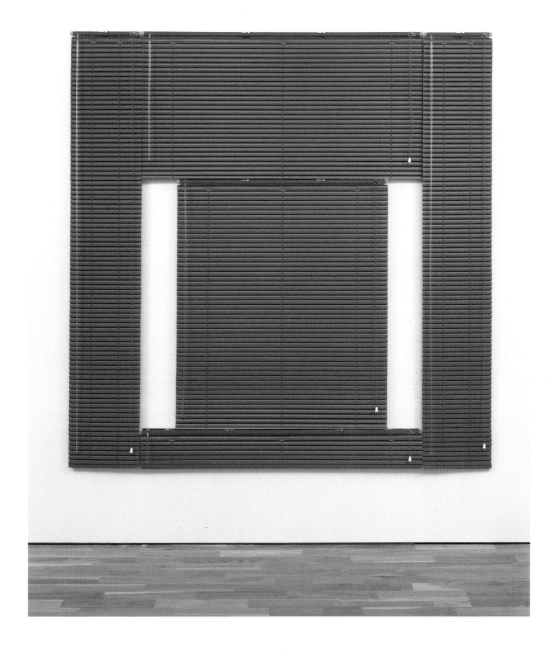

36

UNTITLED (RED) 1989

Venetian-blind, 183 x 183 x 3.2 cms

UNTITLED (BLACK) 1989
Venetian-blind, 243.8 x 243.8 x 3.2 cms

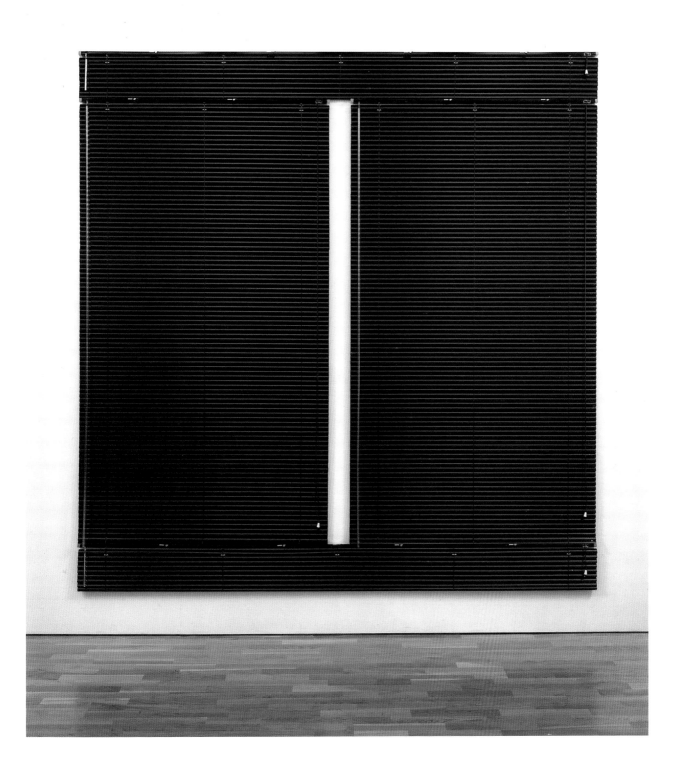

38

UNTITLED (GLOBE) 1989

Household paint on canvas, 183 x 228.6 x 9 cms

(overleaf)

39

UNTITLED (LIGHT BULB) 1989

Household paint on canvas, 213.3 x 426.7 x 9 cms

40

UNTITLED (TELEVISION) 1989

Household paint on canvas, 213.3 x 426.7 x 9 cms

41

UNTITLED (MIRROR) 1989

Household paint on canvas, 213.3 x 426.7 x 9 cms

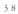

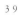
39

SELECTED WRITINGS

MICHAEL CRAIG-MARTIN

Four Identical Boxes with Lids Reversed, 1969

Blockboard, 61 x 244 x 91 cms.
The Trustees of the Tate Gallery, London

(The following statement was written on 30 April 1970 and published in *The Tate Gallery 1968-70,* Tate Gallery Publications, 1970)

'I began making constructions in 1965. The first half dozen of these employed a variety of materials: hardboard, canvas, linoleum, paint, lights. The structures were based on simple letter and number forms. The colours employed were generally limited to silver, white and natural wood finish.

In 1966, wishing to focus more clearly on the idea embodied in each piece and wanting to draw attention away from compositional concerns, I started working entirely in terms of a simple box format. I found that although the box had a strong assertive character, it was highly receptive to the introduction of simple, discrete ideas. The box was also by nature down to earth, utilitarian, familiar, ordinary. It was exactly these characteristics which I wished to examine in terms of real-scale, non-referential objects.

I do not believe that the art object is the symbol of the art idea. It is its embodiment. The relation of idea to object is directly equivalent to the relation of colour, or material, or scale to object. They are all basically formal, i.e. internally determined considerations. I feel that the idea achieves or fails to achieve credence and significance from this relation. The idea of itself can be simple, even banal, and yet give rise to provocative form, which in turn raises the significance of the idea.

4 Identical Boxes with Lids Reversed grew out of work towards another quite different piece. In this original piece there were five identical boxes. Their dimensions were 24″ x 18″ x 18″ each. The lids were cut half-way up the front surface so that when open they would effect the maximum alteration to the reading of each piece. In other words, I wanted the lids to operate as equal partners with the boxes themselves in forming the object that resulted from opening. I did not want them to act as details. The opposite edge of the lids was cut in the top surface at 6″ intervals: 6″, 12″ and 18″ from the front, then 6″ and 12″ down the back. In

this progression at the 5th and last box, the lid and box were identical. It seemed to me that at this point the nature of the progression was disturbed radically although this resulted from following the progression logically.

This piece was never completed. Two drawings exist for it; one is the artist's copy, the other is in a private collection.

Once the lids had been cut from the boxes I was struck by the remarkable differences between the various units. I found it difficult to recognise which lid fitted to which box. The idea occurred to try reversing the lids. As there were five boxes at this point the middle box did not change. The 5th lid, being half the size of a complete box, was too cumbersome and heavy to fit onto the very slight opening in the first box. For these reasons the 5th box and lid were removed from the series.

The piece which now emerged when the lids were reversed, while still as straightforward and simple conceptually as the original, was enormously more complex and elusive visually.

The crucial consideration in the piece is the relation of idea to form. The form derives from the straightforward following through of simple logical ideas, in this case, the idea of taking the progression, and the idea of reversal. Though the form is completely controlled, it is not pre-meditated. The piece both explains and conceals itself.

In the original five unit piece, I had hoped to imply the organisational integrity of symmetry in an asymmetrical situation. The boxes were identical when closed, and, arranged with a regular interval, the piece was symmetrical. Opening the boxes rendered the piece visually asymmetrical, though factually it remained symmetrical.

In these terms, I considered the new piece both more surprising and more successful. With the lids reversed, the boxes are always both visually and factually unique. However, taken as a whole, the piece is still essentially 4 identical boxes. The title emphasises this fact which it is almost impossible to recognise visually. Nothing has been added or taken away. If the idea of taking the progression of lids can be considered to have a direction, reversing the lids cancels this direction conceptually and returns the piece to the original 4 identical boxes.

The piece was painted pale grey so as not to draw attention to itself, and so as to emphasise the complexity of shadows which play through the piece. The textural quality of the paint is intended to relate the tactile quality of the surface to the tactile

meaning of the piece.

Despite the fact that there have been subsequent pieces employing the box format and dealing with related ideas, I consider *4 Identical Boxes with Lids Reversed* to be the culmination of my work in that area. I have found it difficult to develop directly from the piece, because it dominates my attempts to expand its concerns.

The most interesting piece it has given rise to is *Progression of 5 Boxes with Lids Reversed* (1969). This piece also deals with questions such as the relation of idea to form and symmetry/asymmetry. However, it employs as its principal concern the fact, which was eliminated from the 4 box piece, that in a reversal of an odd number of units the centre does not change. . . '

Four Complete Clipboard Sets:
1. Clipboard
2. Sheet of Paper
3. Pencil
4. Written Title
5. Eraser
Extended to 5 Incomplete Sets with Photograph Replacements, 1971

Assemblage of Letrafilm, plastic tape, paper, paper clip, written text and card, in 5 units each 77 x 51 cms., comprising a single work

The Trustees of the Tate Gallery, London

(The following statement was written on 16 July 1972 and published in *The Tate Gallery 1970-72*, Tate Gallery Publications, 1972)

'The set of five drawings, which constitute a single piece, is a representation of five sets of actual objects. The drawings present a situation of virtual identity between real objects and their representations. The result is confusion regarding the nature of identity itself.

To understand the organisational structure of the drawings it is necessary to understand the organisational structure of the objects themselves in the original piece. The original set consisted of five real objects: clipboard, sheet of paper, pencil, written title, eraser. These objects formed a functionally rather than visually based relationship. They were real objects performing their real functions. The clipboard held the paper, the pencil wrote the title, the eraser removed the title. The title enumerated

simply the elements comprising the set and their mode of presentation.

To further expose the nature of the functional relationships, four complete clipboard sets were used and extended to create five incomplete sets. The four sets of five things were extended to five sets of four things by removing one thing from each set, each time a different thing. Each of the five new sets was missing one thing; each of the things missing was different; each of the five sets was different.

The original functional procedure was carried out as far as possible in each set. The first set could be completed. Despite the missing clipboard, the title could be written and erased. The second set could not be completed. As there was no paper, the title could not be written. The third set could not be completed. As there was no pencil, the title could not be written. The fourth set had all the things necessary for the complete procedure but it was not realised because the thing to be omitted was the written title. In the fifth set the written title remained intact. As there was no eraser, the writing could not be removed.

The missing objects were then replaced by a photograph (itself an object) in the position of each missing object. The first photograph shows the clipboard and goes behind the sheet of paper. The second shows the clipboard and the sheet of paper and is clipped in the clipboard. The third shows the clipboard, the sheet of paper and the pencil and hangs from the long piece of string. The fourth shows the clipboard, the sheet of paper, the pencil and the written title and goes on the centre of the sheet of paper. The last shows the clipboard, the sheet of paper, the pencil and the eraser, and hangs from the short piece of string. The title has been written and erased. Thus the final photograph shows the original clipboard set that is no longer present in the piece.

It is this piece which is represented in the set of drawings. Each of the drawings shows one of the incomplete sets with the photograph replacement.

My intention in the original piece was to make a work, using real objects, that did not involve tampering with their essential nature as functional objects. No attempt was made to transcend their ordinary reality. I wished to respect the integrity of the objects, to use objects available to everyone, and to use relationships implied by the objects themselves as the structural basis for the whole. Although the piece is perceived visually and 'read' visually, it is not primarily concerned with visual aesthetics but with the use of visual perception to uncover structure and meaning.

My intention in the drawings was to use the findings of the original piece to create instances of inter-changeable identity between object and image. The representation of the clipboard is obviously not a clipboard despite the fact that it literally holds

the paper. On the other hand the sheet of paper in the drawings both represents and *is identical to* the sheet of paper in the set of real objects. The pencil and the eraser are clearly representations but the title is actually written on the sheet of paper, as in the real set. Its erasure is also identical. The photographs used in the drawings are the same as those used in the real sets, and show not the objects in the drawings but the real objects from the original piece. They are acting as 'representations' of photographs . . .'

Conviction, 1973

8 mirrors, plastic tape and ink, 53.5 x 412 cms.
Each mirror is accompanied by a statement:

I recognise myself

?

I know who I am

?

I understand why I am as I am

?

I accept myself

?

The Trustees of the Tate Gallery, London

(The following statement was written on 16 May 1974 and published in *The Tate Gallery 1972-4 Biennial Report and Illustrated Catalogue of Acquisitions,* Tate Gallery Publications, 1975)

Conviction is one of several related works of 1973. These works all took the same basic form: small vertical rectangles of mirror attached to the wall framed by thin linear rectangles of black adhesive tape. Under each mirror is a hand-written statement in the first person singular. Each piece consists of a series of these units. The number of units varies from piece to piece. The statements are different in each piece. All the pieces are intended to be read from left to right.

These works emerged from an alteration from the concerns of the preceding works with mirrors. In this earlier phase, I had attempted to deal with questions of physical confrontation, either of object, place, self, or others. All were intended to elicit psychological consideration of the physically experienced situation. I decided to try to deal more directly with the question of psychological confrontation of the viewer with himself.

To this end I set out to minimise the mechanics of the mir-

rors as much as possible. I had found that any complexity in how something was done drew attention away from what was done. I decided to use mirrors in the most familiar commonplace manner – flat against the wall and reflecting the face of the viewer. I used small vertical rectangles of mirror so they would be completely filled by the face of anyone confronting them head-on. The black linear rectangles framing the mirrors were intended to help hold the mirror images on the surface of the wall. I did not want the mirrors to act architecturally or as 'holes' in the wall. I wanted them to be like photographs of each participating viewer.

The relation between the mirrors and the statements is intended to be ironic. One reads the statement, reacts as one feels it affects one, and looks at oneself in the mirror. For evidence? For confirmation? For denial? For an answer? It tells everything and nothing. In each succeeding mirror the face is always the same and always different. The mirrors externalise, the statements internalise.

In *Conviction* the question marks deliberately act ambiguously, on the one hand qualifying the certainty of the preceding statement and on the other suggesting the possibility of another statement in place of the question mark. *Conviction* is the only piece where question marks appear alone.

Whereas the statements direct or at least suggest areas of thought, the question marks permit the viewer to 'respond', to initiate his own thoughts that are absorbed into the structure of the piece.

The statements are highly generalised to allow maximum scope for identification. They are intended to establish an area of self-consideration. The statements themselves develop in implied complexity. They go from recognition, to understanding, to knowledge, to acceptance.

Conviction is intended to fuse (in the spectator's experience) privacy (only he/she can see and think what he/she sees and thinks) with embarrassment, springing from the exposed public setting of this private revelation. The piece is related to the confessional in the Church in that there, although the confession is private and anonymous, one is seen to be confessing.

The title of the piece was changed from *?* to *Conviction* for two reasons. First, to emphasise the irony that although the statements express absolute certainty the whole piece elicits doubt. Secondly, the word *Conviction* also implies that a person making such statements (even to himself) convicts himself of arrogance or deceit or delusion . . .'

111

An Oak Tree, 1973

Objects and water, 13 cms. high
National Gallery of Australia, Canberra

(The following was written in October 1985 and published in
Entre El Objeto y la Imagen – Escultura Británica Contemporánea,
British Council and Ministerio de Cultura, Madrid, 1986)

'In 1976 a small retrospective exhibition of my work was arranged to tour Australia. I happily accepted the invitation to fly out and install the first show. I arrived in Brisbane two days before the opening. The gallery director explained anxiously that though the crate containing my work had arrived safely, it had been impounded by the Ministry of Agriculture – without explanation. We went immediately to try to obtain its release. I asked the customs official what was the problem. He thrust the bill of lading in front of me and pointed to the item listed: 'an oak tree'. "No plants allowed", he said firmly, with the satisfied confidence of a man stating the obvious.'

'Taking Things as Pictures'

(First published in Artscribe No. 14, October, 1978)

The presence of light lets many things appear that could not appear in the dark.

Without light, colours and pictures are not present at all.

If we were not creatures capable of letting things appear, the presence or absence of light would make no difference.

Light makes vision possible, not inevitable.

Letting things appear – perceiving – takes place in us.

Letting pictures appear – picturing – also takes place in us.

These are achievements, sudden and without effort.

Picturing occurs when something is taken as a picture of something else.

Picturing requires that an object be taken as a picture, that something be recognized as pictured, and that someone takes the object as a picture.

Picturing is the achievement of the one who takes the object as a picture.

But it is the object that becomes the picture.

Some pictures occur naturally – reflections, for instance, and shadows.

Some pictures are constructed by people – drawings, paintings, sculptures.

Some pictures are produced by mechanical processes – photographs, films, television.

We tend to admire in other people the capacity to make pictures.

But the artist can make pictures only because he is someone capable of taking things as pictures.

Picturing is a pre-condition of picture making.

Picturing is the more essential achievement.

The artist's product is a picture because someone takes it as a picture.

Not everything can be taken as a picture, a glass of water for instance.

Natural pictures, such as shadows and reflections in water or mirrors, are continuously generated in the presence of the pictured.

Live television also provides continuously generated pictures.

The intervening technology makes possible great physical separation between the pictured and the picture (from the surface of the moon to that of the earth for example).

In constructed pictures, the pictured need not be physically present.

In fact, the pictured need no longer exist nor ever have existed.

Picturing can take place in the imagination or in the memory without any physical object being understood to be the picture.

Constructed pictures draw our attention to the object which is absent, the pictured.

Although pictures refer away from themselves to the object pictured, they do not indicate something different from themselves in the way that signs do.

Many symbols are pictures, but they symbolize something different from what they picture.

Pictures do not merely *refer* to the pictured, but make the pictured *present*.

There is a difference between a thing and its presence.

Recognizing that a thing remains itself whether it is present or absent makes naming and picturing possible.

Picturing enables us to experience the presence of a thing without the thing itself.

Pictures are a form of presentation of things.

Pictures manifest both the presence of the object (the picture) and the presence of the pictured.

To see one object as another (to picture) is to create a tension between the presence of the former and that of the latter.

To take something as a picture is to allow the presence of the pictured to overwhelm the presence of the picture.

In our century, pictures have become commonplace: photographs, films, television, advertising.

In art, however, the previously central role of picturing has declined, while the role of forming has grown.

A Jackson Pollock or a Carl Andre is not a picture, any more than a chair is.

Many people mistakenly identify art with picturing and are suspicious of works of art that forego picturing.

Some pictures are art, some are not. Some art pictures, some does not.

Art is what it is because we take it as such.

Much of the 20th century art has emphasized the *actual* experience (the presence) of the work itself over the experience of what could be pictured, which has been taken to be vicarious.

The present renewed interest in photography, figurative painting, and 'socially relevant' art reveals a new concern with picturing.

It has become fashionable to be dismissive of 20th century work in abstraction, as though it could shed no light on the question of picturing.

Picturing itself is being taken for granted, with the result that the models for the 'new' work are being borrowed unquestioningly from the authority of the past.

Language, signs, and pictures are not just aspects of our experience of the world.

They are intimately related to how and what we experience, and what we understand by that experience.

They are also crucially dependent on one another.

Names, pictures, and signs would be impossible without each other.

I am indebted in what I have presented above to an essay by Robert Sokolowski entitled 'Picturing' which appeared in *The Review of Metaphysics* 1977, pages 3-28. Also recommended: *Presence and Absence by* Robert Sokolowski (Bloomington, Indiana, 1978), *On Photography* by Susan Sontag (Allen Lane, London, 1978), *The World Viewed: Reflections on the Ontology of Film* by Stanley Cavell.

'*Reflections on the 1960s and early '70s*'

(First published in *Art Monthly,* March, 1988)

'I have been asked to write some notes about my memories of the period between the late '60s and early '70s. Thinking back on that time, I am aware that my experience and feelings about it are crucially coloured by my time as a student in the early '60s.

I was a painting student at Yale University School of Art between 1961 and 1966. It was a good time to be a student and, I now realise, the golden age of the school. Among the students during that period were Brice Marden, Richard Serra, Chuck Close, Bob Mangold, Nancy Graves, Jon Borofsky, Jennifer Bartlett and Victor Burgin.

My generation was the first to receive formal education at art colleges or art departments of universities as a matter of course. Few of our teachers had had the form of education they sought to give us. For the first time, each year brought forth a new wave of graduates specifically educated to be artists.

It seemed obvioius to us that there were going to be immeasurably more artists than ever before and by the law of averages more good artists. But we were also convinced that this spreading of both talent and opportunity diminished the likelihood of great masters. Warhol's famous quote about 15 minutes of fame was not just a reference to the fleeting nature of modern notoriety, but also its new democratic character: 15 minutes of fame each, for everybody.

The age of the 'artist/genius' did not accord with our sense of contemporary reality and, worse, seemed un-American. Like metaphysics, the concept of genius seemed too grand, too old-fashioned, too European. Ambitions for one's work would be rewarded not primarily as the result of talent, but by hard work,

energy and persistence. Talent implied heredity and heredity implied superiority by birthright: an Old World concept. (I read with bemusement the reaction of both public and press in Chicago in the 1980s to the present retrospective exhibition of the work of Anselm Kiefer – European/artist/genius/seer/metaphysical painter.)

Besides, we could see among our fellow students that those with the greatest conventional talents (they had to be conventional to be recognisable) were often seduced and limited by them. Those without obvious gifts were forced by necessity to discover and develop their own areas of ability. Often these unusual capacities came to form the basis of these artists' originality.

The expansion of art education had the effect of challenging the anti-intellectualism traditional in art institutions. Artists and art students became increasingly interested in reading about contemporary art, art theory and art criticism. The readership of art magazines grew dramatically, as did the number of magazines. I recall a time as a student when everyone was reading John Cage, Buckminster Fuller and Marshall McLuhan. However superficially, many students did become interested in philosophy, psychology, anthropology, systems theory, linguistics and semiology. It seemed natural to think of art as participating actively in the intellectual life of the time.

The expansion of art education coincided with, and undoubtedly helped cause, a loss of confidence not only in traditional academic teaching but also in the basic design/formalist teaching which had largely replaced it.

The pluralist character of the artworld itself, and the success and dominance of artists blatantly breaking with the values of their education underlined the problem of defining what constituted basic skills and principles.

All of these things led us inevitably, I believe, to question the nature of art itself: its meaning and history; its material and visual possibilities; its personal, social and political functions; its limits and limitations.

I remember the period of the early '60s as dominated in New York by painting: the work of de Kooning, Stella, Noland, Louis, Johns, Rauschenberg, Warhol, Lichtenstein, Rosenquist, etc. The issues of contention (pro- and anti-Greenberg, painterly handlings vs. Pop mechanics, representational vs. abstract) were played out principally in the work of painters. Except for Oldenburg and Segal, interest in sculpture was decidedly marginal. Even among the students at Yale whom I've mentioned, only Jon Borofsky was in the sculpture department.

I think of the *Primary Structures* exhibition at the Jewish Museum in April 1966 as marking a critical moment of change. This large scale survey of contemporary sculpture was the first to bring together and focus attention on the work that came to be called Minimal. Although we had seen the work of many of these artists (Judd, LeWitt, Morris, Andre, Flavin) during the previous year or two, this exhibition consolidated their importance and originality and clarified the differences between their work and other superficially similar work in the exhibition (Neo-Constructivism, New Generation English Sculpture).

Some years would pass before it became commonplace to say painting was dead, but I do not think painting occupied the foreground of art again until the beginning of the '80's. Many of the most interesting young artists stopped painting and turned to other things. Minimalist sculpture was primarily the work of former painters.

I think of Minimalism as the last great modern aesthetic.

Minimalism sought to demystify art, to reveal its most fundamental character, its reality. It was confident, serious and high minded without being metaphysical or 'spiritual'. Exposing its materials and processes, it attempted to engage the viewer in an immediate, direct and unmediated experience. Minimalism was in essence an attitude, not a style, and the appearance of Minimalist work was a consequence of that attitude. The work was uncompromisingly radical and challenging: it proposed a new way of looking at the world. Many of the artists were exceptionally articulate: for example Judd's years of art criticism, Robert Morris's regular articles in *Artforum*.

Minimalism is often misunderstood as negative, nihilist, empty. In fact, the apparent simplicity of Minimalist works focuses attention without distraction of the straight-forward reality of the object, the relation of the object to the space in which it is seen, the relation of the viewer to this experience. This is neither simple nor an art of exclusion. The implication of art based on ordinary experience, using ordinary materials and objects, and making explicit the role of the viewer seems to me to be clear.

I emphasise this because I do not think it is possible to account for the art that followed, including Conceptualism, without understanding the importance and impact of Minimalism on my generation of artists, and certainly on me. Although Minimalism and Conceptualism are different and distinct, much of what I have said about the former could be applied to the latter. Minimalism provided a framework of attitudes that taken further made whole areas of life, experience and expression, previously considered outside the realm of art, available to artists.

Conceptualism seems to me to have been the consequence of the conjunction of several impulses. The acceptance of the literal characteristics of material as expressive in Minimalism opened possibilities in an immense range of materials and processes of making. The extension of material reductivism in-

herent in Minimalism inevitably led to dematerialisation and finally to language itself. The increasing involvement of artists themselves in questions of art theory narrowed the distinction between art practice and art theory. The extreme limitations on critically acceptable areas of concern, especially in painting, had created among artists great frustration with the content of art.

I made my first construction in September 1965. It was based on the images in my paintings: I simply constructed them using painted and sewn canvas, fur, fablon, and steel bolts. The experience was a revelation. I never made another painting. Over that year I made objects using the same materials and also aluminium paint, electric lights, linoleum, unprimed canvas and plywood. O Plywood! It is difficult now to describe the sheer pleasure of making a work out of plywood using one's own Black and Decker jig-saw. Neither the material nor the tool had yet acquired any art implications.

On finishing at Yale in 1966, I came to England, where I had been offered a teaching job at the Bath Academy of Art. A very long way from Yale and New York in time as well as distance. A long way from London too.

It occurs to me that in some respects Britain now is very much like America was then. I came from the world of giant shopping malls, highway superstores, do-it-yourself suburbia, two car families and domestic gadgets: the North Circular Road of today. Rural Wiltshire in 1966 was rather different. The ironmonger and the timber merchant; the incredible scarcity of materials; the difficulty of finding 4 x 8 ft. sheets of plywood; the lack of choice; the high cost of ordinary building materials.

The work I did during those years, with little direct contact with the ideas and culture I came from, were the *Box Pieces* that formed my first show at the Rowan Gallery in 1969. These works took the scale and form of domestic furnishings. They were made of plywood coated with household paint or formica and used commercial hinges and cabinet fittings. These were the first works in which I tried to employ the ordinary functioning of an object (in this case the opening and closing of the box) in establishing its status as a work of art, instead of as an object of use.

During those first years in England only a few artists I met were familiar with or interested in the work of the Minimalists. Victor Burgin, returning to Britain in 1967 from Yale, had had direct contact with the new artists and was well informed about their work and ideas. The first British art publication to draw serious attention to Minimalism was *Studio International*, which devoted its entire April 1969 issue (largely organised by Barbara Reise) to the subject. This coincided with *The Art of the Real* exhibition at the Tate. Though not a specifically Minimalist exhibition this was the first time Minimalist work was shown in Britain. In August the ICA showed *When Attitudes Become Form*,

the first group show of what came to be called Conceptual art. Like *The Art of the Real* this exhibition was organised by a European museum and reached London as the last stop of a long tour. The first one-man exhibition was work by Don Judd at the Whitechapel, late in 1970. The first Minimalist sculpture purchased by the Tate was Robert Morris's *Untitled 1967-68*, a hanging fibreglass piece acquired in 1970. *Equivalent VIII*, though executed in 1966, was not purchased until 1972.

As these exhibitions occurred within months of each other Minimalism and Conceptualism were initially experienced in Britain simultaneously. There was no Minimalist period here, though there were to be Minimalist British artists. Whereas I think of Minimalism as essentially a New York art, Conceptualism from the very beginning seemed international. Quite suddenly, it became clear that for several years artists in countries all over the world had been working in ways and with materials outside painting and sculpture. Obviously interesting and important work was being done all over Western Europe, North America and elsewhere. Even Eastern European countries, particularly Poland, had artists at the forefront of the new art. Language, cultural and historical differences no longer seemed to act as barriers and divide art. Although New York still functioned as a focal point, no one place could claim to be the centre.

I want to say something about why I think this unique phenomenon occurred.

All art depends for its production and understanding on context and history. Art does not occur in a personal or social vacuum. Traditional forms of art, particularly painting, require a period of learning in order to gain perceptual experience and technical skills – familiarity with disciplined looking and with handling the medium. In a society of universally shared traditions and values, teaching along such lines is possible (essentially apprenticeship). In our fragmented and polyglot society, the requirements of one kind of painting can be different from, and even contradictory to, those of another. Despite this, painting is often taught as though it were a simple, neutral language which, once learned, could be applied in any circumstance. The awkward fact that one way of working predisposes certain results and excludes the possibility of others, is simply ignored. This teaching gives little consideration to the central question of what the painting is meant to do or say, and takes questions of context and history for granted.

What Minimalism made explicitly clear was that the language used determines the meaning of the statement. Conceptualism was the explosion of this concept into all forms of expressive language. It was also the realisation that everything in the world held the potential of language. Art could be found anywhere and made of anything.

Artists now approached language as the question of what is appropriate for my needs, for what I wish to say or do. They sought out in different language forms the latent structures by which meaning was carried, and made them visible. Artists looked out at the world, not into themselves, in order to speak.

The reason the new art spread across the world was because of this directness of approach to language. It was not necessary to spend years learning a craft in the hope that one day one would 'find oneself' in it. Everyone knows that by having a clear reason to learn something, one learns quickly. Artists in societies without a significant contemporary tradition of painting and sculpture found themselves in a situation comparable with artists working in well-known cultural centres. With lively imaginations and little inhibiting excess baggage, the young everywhere were positively advantaged. I spent a lot of time engaged in teaching during these years. I was fascinated because, in a way quite different from any other time, students regularly produced work as interesting and advanced as one saw in the galleries.

The context of this new work was provided by publications – art magazines, artists' books and catalogues – and international exhibitions. As much of this work employed photographs and/or the written or printed word, it was exceptionally suited for publication. The character of much of the work made it possible to send it through the post, to carry it in suitcases, to make it on site in exhibitions, or simply remake it in each venue. Large-scale group exhibitions could be organised for comparatively little money: limited shipping and insurance costs. The need for the artist to travel to exhibitions, however distant, meant that many artists travelled regularly and met foreign artists whose work they recognised from publications. Artists of modest reputation shared something of the professional life previously only experienced by the very successful.

The new work also made possible a new type of gallery. Single rooms in office buildings, small shop fronts, enormous spaces in old industrial buildings were opened as galleries. I remember having an exhibition in a gallery in Germany where the dealer slept on a camp bed in the office because he could not afford a flat. Little money, certainly by contemporary standards, was made either by artists or gallery directors, but there was a tangible atmosphere of being engaged in a vital international cultural phenomenon. Major exhibitions of historical importance took place in extraordinary circumstances often in previously obscure provincial European cities. Unquestionably the most important exhibition of the Conceptual period was *The New Art* at the Hayward Gallery in 1972, selected by Anne Seymour. The artists included were Richard Long, Gilbert & George, Hamish Fulton, John Hilliard, Art & Language, Barry Flanagan, Keith Arnatt, David Dye, Keith Milow, Gerald Newman, John Stezaker, David Tremlett and myself.

During these years my work continued to be focussed on questions about the nature of objects. The boxes, though simple, functioning objects, were hand-made and unique. Increasingly I became interested in the ready-made, the mass-produced, the store-bought, the cheap and new. I made work using buckets, milk bottles, tables, shelves, clip boards, electric fans, pots of paint, mirrors, etc. In all these works, my intent was to make art without transformation of the material. I felt that transformation was assumed to be the bottom line of basic requirements for a work of art. (Even Duchamp's ready-mades withdrew the objects from their intended usage: the stool and the bicycle wheel, and of course, the urinal . . .) I intended to disprove this notion. The culmination of this work was *An Oak Tree* of 1973, originally shown on its own at the Rowan Gallery. The piece consisted of an ordinary drinking glass of water, on a glass shelf fixed nine feet high on the wall, accompanied by a text in the form of an auto-interview in which I claimed to have changed the glass of water into an oak tree despite appearances to the contrary. The success of this work was confirmed some years later when, on being shipped to Australia for exhibition, it was confiscated by the Agriculture Division of Customs for seeking to circumvent the law preventing the import of living plants.

Like all other movements in art, Conceptualism gradually declined into academicism, leaving in its wake a considerable number of still interesting artists. The decline of the movement shocked many of the artists involved because we did not consider what had happened as just another style or -ism, and because we had assumed that the constant renewal of language would prevent hardening of the arteries. We were wrong: the characteristics of the art of the period turned out to be just that.

Now in the late Post-Modern 1980s when everything not only gives one a sense of world weary *déjà vu* but proclaims it, I am thankful to be able to recall that period when I regularly found myself confronted with a work of art which challenged my assumptions about art and left me in stunned amazement.'

'The Art of Context'

(First published in *Minimalism*, Tate Gallery Liverpool, 1989)

'At the beginning of the 1960s Abstract Expressionism seemed to mark both the triumph of American painting and the emergence of a recognizably new and radical post-War aesthetic.

Today Abstract Expressionism retains its dominant inter-

national position in the art of the late '40s and early '50s, but with each succeeding decade its connectedness and continuity with pre-War European art become clearer and its separateness and distinction from the art which has succeeded it become increasingly apparent. This is not to deny or diminish the great originality and achievement of Abstract Expressionism, but to see it as the triumph of early 20th century Modernism in the New World. The confident romantic idealism, the sense of extreme personal engagement, the unselfconscious moral heroism that characterized Abstract Expressionism had their roots in the years of material deprivation and communal social awareness of the Depression and the War.

I was a student in America in the early '60s, part of the generation born during the War but with little direct memory of it, knowing only a world of steadily increasing affluence and seemingly limitless opportunity, a world of the new suburbia and its invention the 'teenager', of rock and roll, television, the two car family, and the drive-in. For my generation of art students, the high-mindedness of Abstract Expressionism, while overwhelmingly admired, created the embarrassed silence of cultural distance.

This is not to imply a lack of seriousness about art on our part (if anything, the contrary was true) but that a self-conscious emotional gap had opened between the artists whose formative experience was essentially pre-War and those for whom it was post-War. For us, the first artists to provide the possibility of instinctive identification were Jasper Johns and Robert Rauschenberg. With the benefit of hindsight, it is clear that these two artists were the first to manifest the dominant characteristics of much of the art of the subsequent twenty years.

Detachment; irony; use of commonplace objects and imagery; use of secondary imagery, repeated units, mechanical processes; linguistic and conceptual concerns; interest in perceptual psychology and the role of the viewer; fascination with both the concept of reductivism and the work of Duchamp; acceptance of meaning latent in different materials and in the process of making; openness to the use of any and all materials; indifference to the apparent divisions between high and low culture; indifference to the distinction between abstraction and representation; denial of hierarchy; denial of absolute values; commitment to a notion of the radical based on continual questioning of fundamental assumptions; primacy given to simplicity, clarity, directness and immediacy; assertion of the physical rather than the metaphysical or the metaphoric; these characteristics are apparent in the critical art of the '60s: Pop, Minimal, and Conceptual. 'Cool art', in the terms of Marshal McLuhan, rather than the 'hot art' of the '50s.

The conjunction of these new attitudes and ideas created an explosion of creative possibilities; new ways of making and understanding art, new ways of looking at the world. Despite their important and obvious differences, these three movements together, I believe, constitute an aesthetic realm whose radical challenge continues to the present.

When we assumed that radical and fundamental questioning of art and the invention of essentially new forms of language were basic to the nature of all new art, we were wrong. These ideas were, in fact, central to the art of that particular period from the late '50s to the mid-'70s and can be seen now to have been the principal determinants of the character of the art of that time. In retrospect it is obvious that the pressure of fundamental innovation was unsustainable, that a new form of academicism was inevitable, and that a period of 'return to the old values' would follow.

The art of the '80s has of course been dramatically different from the art of the previous period, with the re-emergence of painting (painterly, self-expressive, figurative, narrative, romantic, heroic) as the primary vehicle of art. In general, with some individual exceptions, the art of the past decade has depended for its sense of newness and innovation simply on its difference from Conceptual and other art which immediately preceded it. Particularly in Britain 'the new spirit of painting' has essentially seen the consolidation of the reputations of those painters who have come to be known as the School of London, the character of whose work was already clear by the later '50s or early '60s, and who, I suspect, have never even thought of themselves in the terms of radical innovation, a concept foreign to their conservative and romantic individualism.

What the radical art of the '60s had proposed was not simply new styles of painting and sculpture but an alternative attitude toward art, toward art making, toward art meaning. This is most clear in the continuing challenge of Minimalism.

The public enjoyed Pop Art even before it was taken seriously by the art world: people found a lot to 'relate to'. Because Conceptual art never developed recognizable stylistic conventions, and because, in its broadest definition, it came to cover an extensive range of activities, it never intruded in a focussed way on public consciousness. Minimalism, with its implication of 'almost nothing there' and, in Britain, because of the notoriety of the Carl Andre 'brick piece', has come to represent everything about contemporary art that makes many people (not just those that are uninterested in art) suspicious and hostile. This reaction is based partly on misunderstanding and partly on a rejection of the radically different values Minimalism represents.

As Barbara Rose pointed out in her article 'ABC Art' in *Art in America* in October 1965, Minimalism arose from a strange syn-

thesis of the two most radical polarities of early twentieth century art: Malevich placing a black square on a white ground, and Duchamp exhibiting a standard bottle rack, a 'ready-made'. Malevich with his realization that art did not need to be visually complex to provide a complex experience and Duchamp with his denial of the necessity of the uniqueness of the art object, and his realization that art is itself a context, were seeking to demystify art and to create an art directly accessible to the viewer without the need of intermediaries, 'interpreters'. The Minimalists shared these aims.

Radical art never creates anything entirely new: it simply shifts the emphasis. What previously was unimportant, taken for granted, invisible, becomes central. Minimalism seeks the meaning of art in the immediate and personal experience of the viewer in the presence of a specific work. There is no reference to another previous experience (no representations), no implication of a higher level of experience (no metaphysics), no promise of a deeper intellectual experience (no metaphor). Instead Minimalism presents the viewer with objects of charged neutrality: objects usually rectilinear, employing one or two materials, one or two colours, repeated identical units, factory-made or store-bought; objects that are without any hierarchy of interest, that directly engage and interact with the particular space they occupy; objects that reveal everything about themselves, but little about the artist; objects whose subject is the viewer.

By shifting the emphasis so emphatically to direct experience, Minimalist art makes a clear statement about the nature of reality. Its apparent simplicity is the result of rigorous focussing, the elimination of distraction. It is neither simple nor empty, cold nor obscure. Minimalism reorders values. It locates profound experience in ordinary experience.'

CATALOGUE

Dimensions are given in centimetres, height before width before depth.

In 1975 works stored in a London studio were destroyed by fire and the artist has taken the opportunity afforded by this exhibition to remake a number of these.

FORMICA BOX
1968 (remade in 1989)
Formica on plywood
121.9 x 121.9 x 61
The artist, courtesy of Waddington Galleries
Plate nos. 1 & 2

LONG BOX
1969 (remade in 1989)
Painted plywood, 61 x 366 x 46
The artist, courtesy of Waddington Galleries
Plate nos. 3 & 4

FOUR IDENTICAL BOXES WITH LIDS REVERSED
1969
Painted blockboard, 61 x 244 x 91
The Trustees of the Tate Gallery
Plate nos. 5 & 6

PROGRESSION OF FIVE BOXES WITH LIDS REVERSED
1969 (remade in 1989)
Plywood coated with clear sealer
61 x 411.5 x 76.2
The artist, courtesy of Waddington Galleries
Plate no. 7

COUNTER-WEIGHT ENCLOSED AND EXPOSED
1970 (remade in 1989)
Lead, nylon rope and mild steel
963 x 963 x 8.8
The artist, courtesy of Waddington Galleries
Plate no. 8

EIGHT FOOT BALANCE WITH TWO REINFORCED PLYWOOD SHEETS
1970 (remade in 1989)
Wood and mild steel,
183 x 488 x 244
The artist, courtesy of Waddington Galleries
Plate no. 10

SIX FOOT BALANCE WITH FOUR POUNDS OF PAPER
1970
Mild steel, paper (lithographic image) and lead
109.5 x 195.3 x 8.8 cms
The artist, courtesy of Waddington Galleries
Plate no. 9

ON THE TABLE
1970
Objects and water
122 cms. square, variable height
Jessica Craig-Martin
Plate no. 12

ON THE SHELF
1970
Objects and water
51 x 109 x 15, edition of 3
James Hopkins (the other two belong to the Australian National Gallery, Canberra, and a private collector)
Plate no. 11

ASSIMILATION
1971
Assorted objects, 7.92 metres long
The artist, courtesy of Waddington Galleries
Plate no. 14

FOUR COMPLETE SHELF SETS . . . EXTENDED TO FIVE INCOMPLETE SETS
1971 (partially remade in 1989)
Assorted objects, 210.8 x 33 x 15.2
The artist, courtesy of Waddington Galleries
Plate no. 13

FORWARDS AND REVERSE
1972 (remade in 1989)
Paint on mirrors, metal brackets
Each mirror 30.4 x 12.7
The artist, courtesy of Waddington Galleries
Plate nos. 15 & 16

SOCIETY
1973
Mirror, tape and handwriting on wall
11 units, each 53.3 x 38.1
The artist, courtesy of Waddington Galleries
Plate no. 17

AN OAK TREE
1973
Objects, water and printed text
13 cms. high
Australian National Gallery, Canberra
Plate no. 18

SLEIGHT-OF-HAND
1975
Neon, 57 x 63.5 x 5
The artist, courtesy of Waddington Galleries
Plate no. 19

A SHORT FILM FOR ZENO
1975
Neon, 110 x 84 x 5
The artist, courtesy of Waddington Galleries
Plate no. 20

PACING
1975
Neon, 76 x 67 x 5
The artist, courtesy of Waddington
Galleries
Plate no. 21

UNTITLED PAINTING NO. 1
1976
Oil on canvas, 122 x 122
Southampton City Art Gallery
Plate no. 24

UNTITLED PAINTING NO. 2
1976
Oil on canvas, 122 x 122
Alex Gregory-Hood
Plate no. 23

UNTITLED PAINTING NO. 4
1976
Oil on canvas, 183 x 183
The artist, courtesy of Waddington
Galleries
Plate no. 22

HAMMER, SANDAL,
SARDINE TIN
1978
Tape on wall, variable dimensions,
size determined at each installation
N. Medhurst
Plate no. 25

UNTITLED WALL DRAWING
1979
Tape on wall, variable dimensions,
size determined at each installation
Ulster Museum, Belfast
Plate no. 26

READING (WITH GLOBE)
1980
Tape on wall, variable dimensions,
size determined at each installation
The Trustees of the Tate Gallery
Plate no. 28

MODERN DANCE
1981
Tape on wall, variable dimensions, size
determined at each installation
The artist, courtesy of Waddington
Galleries
Plate no. 27

MAN
1984
Oil on aluminium panels with painted
steel rods, 233.7 x 132 x 30.5
Ferens Art Gallery: Hull City Museums
and Art Galleries
Plate no. 29

METRONOME
1985
Oil on aluminium panels with painted
steel rods, 96.5 x 137 x 17.7
Jacobson Townsley & Co.
Plate no. 31

THE THINKER
1985
Oil on aluminium panels with painted
steel rods, 184.4 x 144.8 x 22.9
Dr. and Mr. Michael Harris Spector
Plate no. 30

GLOBE
1986
Oil on wood with painted steel rods
82.5 x 52 x 53.4
Private collection
Plate no. 33

SIDE-STEP
1987
Aluminium and painted steel rods with
aluminium ladder, 182.9 x 68.6 x 10.2
Private collection
Plate no. 32

STILL LIFE WITH INTERIOR
1987
Aluminium, painted steel rods and
perspex light box, 247 x 214 x 25.4
The artist, courtesy of Waddington
Galleries
Plate no. 34

UNTITLED (BLACK)
1989
Venetian-blind, 183 x 183 x 3.2
The artist, courtesy of Waddington
Galleries
Plate no. 35

UNTITLED (RED)
1989
Venetian-blind, 183 x 183 x 3.2
The artist, courtesy of Waddington
Galleries
Plate no. 36

UNTITLED (BLACK)
1989
Venetian-blind, 243.8 x 243.8 x 3.2
The artist, courtesy of Waddington
Galleries
Plate no. 37

UNTITLED (GLOBE)
1989
Household paint on canvas
183 x 228.6 x 9
Waddington Galleries
Plate no. 38

UNTITLED (LIGHT BULB)
1989
Household paint on canvas
213.3 x 426.7 x 9
The artist, courtesy of Waddington
Galleries
Plate no. 39

UNTITLED (TELEVISION)
1989
Household paint on canvas
213.3 x 426.7 x 9
The artist, courtesy of Waddington
Galleries
Plate no. 40

UNTITLED (MIRROR)
1989
Household paint on canvas
213.3 x 426.7 x 9
The artist, courtesy of Waddington
Galleries
Plate no. 41

BIOGRAPHY AND BIBLIOGRAPHY

BIOGRAPHICAL NOTES

1941 Born 28 August in Dublin, Ireland, son of Paul and Rhona Craig-Martin.

1941-45 During the War years lives in London and Wales. Father, an agricultural economist, working for British Ministry of Food.

1945 Family moves to Washington, D.C., where father works for F.A.O., and later joins the newly established World Bank.

1947 Attends Roman Catholic school in Washington, D.C. Extensive summer travel in Europe every three years during father's 'home leave' to Dublin.

1955-59 Attends The Priory School, Washington, D.C., an English Benedictine high school.

1957 Father working temporarily in Bogota, Colombia; attends Lycée Français, Bogota; first drawing classes with Spanish artist Antonio Roda.

1958 Returns to Washington, D.C., and resumes education at The Priory School; attends drawing classes given by Washington artists.

1959 Fordham University, New York City, studying English Literature and History; painting in spare time.

1961 Summer in Paris drawing and painting at the Academie de la Grande Chaumière.
Transfers in autumn to Yale College, Yale University, New Haven, Connecticut, majoring in painting; meets graduate students Richard Serra, Chuck Close, Brice Marden, Nancy Graves. Though Josef Albers had recently retired, the school continues to be founded on his courses – Basic Design, Colour, Basic Drawing. All undergraduates and post-graduates have to take these courses; studio work (painting and sculpture) is individually determined; tutors include Al Held, Alex Katz, Neil Welliver.
During this period, sees several one-man exhibitions (Warhol, Lichtenstein, Rosenquist), Johns's 1964 exhibition at the Jewish Museum and *Primary Structures* (LeWitt, Judd, Andre, Morris) also at the Jewish Musuem, 1966.

1963 Marries fellow student, painter Jan Hashey. Graduates from Yale with B.A. degree in painting. Summer in London with temporary job as stringer for *Newsweek* magazine, following Christine Keeler twelve hours a day during the trial of Stephen Ward (Profumo scandal).
Accepts teaching job at The Mountain School, Vershire, Vermont.
Daughter Jessica born, Hanover, New Hampshire.

1964 Returns to Yale as post-graduate student in Painting Department of the School of Art and Architecture; Jack Tworkov is new head of School; visiting tutors include Al Held, Jim Dine, Frank Stella, James Rosenquist, Claes Oldenburg; among fellow students are Jon Borofsky, Jennifer Bartlett, Victor Burgin.

1966 Receives M.F.A. degree.
Accepts offer of teaching job from Clifford Ellis, Principal of Bath Academy of Art, Corsham, Wiltshire; fellow tutors include Mark Lancaster, Malcolm Hughes, Michael Kidner, Tom Phillips; lives with his family in Corsham.

1968 Moves to Blackheath, London, continues to teach at Corsham as well as Canterbury College of Art.

1969 First one-artist exhibition at the Rowan Gallery, Bruton Place, London (shows boxes); regular one-artist exhibitions at Rowan throughout 1970s.

1970-72 Appointed Artist-in-Residence at King's College, Cambridge, which enables him for the first time since art school to devote full time to his own work; lives in Cambridge.

1972 Returns to London, lives in Hackney.
Resumes teaching at Canterbury College of Art. Included in two major group exhibitions *The New Art* (Hayward Gallery) and *7 Exhibitions* (Tate Gallery).

1973 Separates from wife Jan who returns to New York. Offered full-time teaching post at Goldsmiths College of Art, London, by its Principal, Jon Thompson; responsible for group of 25-45 students mostly working outside conventional painting and sculpture; part-time tutors at Goldsmiths include Richard Wentworth, Tim Head, Yehuda Safran, Rita Donagh.

1974 Lives and works in Bayswater, London.

1978 Touring one-artist exhibition of work 1968-78 shown in several Australian cities; after attending Brisbane opening of exhibition, travels extensively in Australia and the Far East, including Hong Kong, Tokyo and Kyoto.

1981 Joins the Waddington Galleries, London, at the invitation of Hester van Royen and has first one-artist show there in 1982.

1981-82 Spends year living and working in New York.

1982 Second visit to Japan (for *Aspects of British Art Today*) and visits India (British representative, with Tony Cragg, in the Fifth Triennale, New Delhi). Returns to London, living and working in Primrose Hill.

1983 Reduces teaching at Goldsmiths to part-time.

1987 Moves to newly converted living space and studio, North London.

1989 Appointed Trustee of the Tate Gallery.

ONE MAN EXHIBITIONS

1969 Rowan Gallery, London

1970 Rowan Gallery, London

1971 Arnolfini Gallery, Bristol
Richard Demarco Gallery, Edinburgh

1972 Rowan Gallery, London

1973 Rowan Gallery, London

1974 Rowan Gallery, London
Galerie December, Münster

1975 Rowan Gallery, London

1976 Rowan Gallery, London
Michael Craig-Martin: Selected works 1966-1975, Turnpike Gallery, Leigh, toured to Arnolfini Gallery, Bristol; I.C.A. New Gallery, London; Glynn Vivian Art Gallery & Museum, Swansea; Cartwright Hall, Bradford; Third Eye Centre, Glasgow (into 1977)

1977 Oliver Dowling, Dublin

1978 Galerie December, Düsseldorf
Michael Craig-Martin, 10 Works 1970-1977, Institute of Modern Art, Brisbane, toured to Coventry Chandler Gallery, Sydney; Ewing & George Paton Gallery, Melbourne; University Union, Melbourne; Adelaide College of Art & Education, Adelaide; Newcastle Region Art Gallery, Newcastle, New South Wales
Rowan Gallery, London

1979 Galeria Foksal, Warsaw, Poland
Galeria Akumlatory, Poznan, Poland
Oliver Dowling Gallery, Dublin

1980 Rowan Gallery, London
Galerie Bama, Paris

1981 Galerija Suvremene Umjetnosti, Zagreb

1982 Fifth Triennale, New Delhi
Waddington Galleries, London

1984 Waddington & Shiell Gallery, Toronto

1985 Waddington Galleries, London

1986 Waddington & Gorce, Montreal

1987 Zack Schuster Gallery, Florida

1988 Waddington Galleries, London

GROUP EXHIBITIONS

1970 *Critics Choice*, Arthur Tooth & Sons, London (selected by Norbert Lynton)
Drawings from Sculpture, C.A.Y.C., Buenos Aires
Works on Paper, Canterbury

1971 Richard Demarco Gallery, Edinburgh
Art Spectrum, Alexandra Palace, London

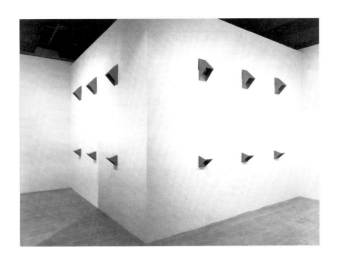

Six Views of an Electric Fan, 1972
Mirrors, metal brackets and 2 electric fans
Installation for *The New Art*, Hayward Gallery

Six Views of an Electri Fan, 1972
(View in one mirror)

1972 *7 Exhibitions*, Tate Gallery, London
 The New Art, Hayward Gallery, London

1973 *Graphics*, Rowan Gallery, London
 11 British Artists, Staatlichen Kunsthalle, Baden-
 Baden, toured to Kunsthalle, Bremen
 Henry Moore to Gilbert & George, Palais des Beaux-
 Arts, Brussels

1974 *Tables*, Garage Art, London
 Critics Choice, Arthur Tooth & Sons, London
 (selected by Marina Vaizey)
 Idea and Image in Recent Art, Art Institute of Chicago
 British Sculptors' Drawings, Ceolfrith Arts, Sunderland
 Arts Centre
 Graphics, Rowan Gallery, London
 Art as Thought Process, Serpentine Gallery, London

1975 C.A.S. Art Fair, Mall Galleries, London
 From Britain 1975, Taidenhalli, Helsinki
 IX Biennale des Jeunes Artistes, Paris
 Body and Soul (Peter Moores Liverpool Project 3),
 Walker Art Gallery, Liverpool
 Mixed Exhibition, R.I.B.A., London
 Contemporary British Drawings, XIII Bienal of Sao
 Paulo
 Britanniasta 75, Helsingin Taidehalli, Helsinki;
 toured to Alvar Aalto-Museo, Jyvaskyla; Tampereen
 Taidemuseo, Tampere

1976 *Art as Thought Process*, XI Biennale International
 d'Art, Palais d'Europe, Menton
 Sydney Biennale, Art Gallery of New South Wales,
 Sydney

1977 *Documenta VI*, Kassel, West Germany
 Hayward Annual: Current British Art Part II, Hayward
 Gallery, London
 Group exhibition, Rowan Gallery, London
 Reflected Images, Kettles Yard Gallery, Cambridge
 *Works on Paper - The Contemporary Art Society's Gifts to
 Public Galleries 1952-1977*, Royal Academy, London

1978 *The Garden*, Jardin Botanique National, organised by
 Musées Royaux des Beaux-Arts de Belgique, Brussels
 Small Works and Drawings by Gallery Sculptors, Rowan
 Gallery, London
 John Moores Liverpool Exhibition XI, Walker Art
 Gallery, Liverpool

1979 *Un Certain Art Anglais*, Musée d'Art Moderne de la
 Ville de Paris, organised by ARC II and the British
 Council
 Tolly Cobbold/Eastern Arts 2nd National Exhibition,
 Fitzwilliam Museum, Cambridge
 Books for Artists, Felicity Samuel Gallery, London
 JP II, Palais des Beaux-Arts, Brussels, organised
 jointly with the British Council
 Sculptors' Drawings, The Minories, Colchester

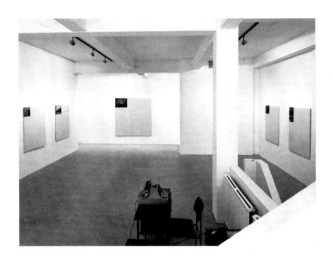

Installation, Rowan Gallery, London, 1976

1980 *John Moores Liverpool Exhibition XII*, Walker Art
 Gallery, Liverpool
 The International Connection, Sense of Ireland Festival,
 Roundhouse Gallery, London
 ROSC, University College Gallery and National
 Gallery of Ireland, Dublin
 Crawford Gallery, Cork

1981 *Tolly Cobbold/Eastern Arts 3rd National Exhibition*,
 Fitzwilliam Museum, Cambridge
 Malmoe, Konsthall, Malmo, Sweden
 Construction in Process, Lodz, Poland
 British Sculpture in the 20th Century, Whitechapel Art
 Gallery, London

1982 *Aspects of British Art Today*, Metropolitan Museum,
 Tokyo, toured to other venues in Japan

1983 *Drawing in Air - an exhibition of sculptors' drawings
 1882-1982*, Sunderland Arts Centre, touring
 exhibition
 Group VI, Waddington Galleries, London
 Tolly Cobbold/Eastern Arts, 4th National
 Exhibition, Fitzwilliam Museum, Cambridge and
 tour

1984 *Groups VII*, Waddington Galleries, London
 1965-1972 - when attitude became form, Kettle's Yard,
 Cambridge and Fruitmarket Gallery, Edinburgh
 The British Art Show, Arts Council of Great Britain

touring exhibition: City Museum and Art Gallery
and Ikon Gallery, Birmingham; Royal Scottish
Academy, Edinburgh; Mappin Art Gallery, Sheffield;
Southampton City Art Gallery

1985 *Still Life, a New Life*, Harris Museum and Art
 Gallery, Preston, and Cartwright Hall, Bradford
 The Seventies, Juda Rowan Gallery, London
 The Irresistible Object: Still Life 1600-1985, Leeds City
 Art Gallery

1986 *Entre El Objeto Y La Imagen - Escultura británica
 contemporánea*, British Council touring exhibition:
 Palacio Velázquez, Madrid; Fundació Caixa de
 Pensions, Barcelona; Museo de Bellos Artes, Bilbao
 L'Attitude, Galeria Comicos, Lisbon, Portugal
 Sculpture, Waddington Galleries, London

1987 *Vessel*, Serpentine Gallery, London
 Wall Works, Cornerhouse Gallery, Manchester
 Something Solid, Cornerhouse Gallery, Manchester

1988 *Starlit Waters: British Sculpture, An International Art
 1968-1988*, Tate Gallery, Liverpool
 Britannica: Trente Ans de Sculpture, Musée des Beaux-
 Arts André Malraux, Le Havre, toured to Musée
 d'Evreux-Ancien Evêché; L'Ecole d'Architecture de
 Normandie, D'Arnétal-Rouen; Museum Van
 Hedendaagse Kunst, Antwerp; Centre d'Art
 Contemporain Midi-Pyrénées, Labège-Innopole,
 Toulouse
 *That Which Appears Is Good, That Which Is Good
 Appears*, Tanja Grunert Gallery, Cologne
 100 Years of Art in Britain, Leeds City Art Gallery,
 100th Anniversary Exhibition

1989 *Corsham - A Celebration*, Victoria Art Gallery, Bath,
 toured to Brighton Polytechnic Gallery and Michael
 Parkin Gallery, London
 Sculpture, Six Friedrich Gallery, Munich
 Michael Craig-Martin, Grenville Davey, Julian Opie, Lia
 Rumma Gallery, Naples
 Subject: Object, Nicola Jacobs Gallery, London

PUBLIC COLLECTIONS

Allen Art Museum, Oberlin College, Ohio
Arts Council of Great Britain
Australian National Gallery, Canberra
Baltimore Museum of Art
Basildon Arts Trust
British Council
Contemporary Art Society, London
Contemporary Art Society for Wales
Ferens Art Gallery, Hull
Fitzwilliam Museum, Cambridge
Southampton City Art Gallery
Swindon Art Gallery
Tate Gallery, London
Victoria & Albert Museum, London
Walker Art Gallery, Liverpool

COMMISSIONS

1975 Margate District Council

1983 Midland Bank, New York

1984 Colchester District General Hospital, Essex

1988 Hasbro-Bradley U.K. Ltd., Stockley Park, Middlesex

SELECTED BIBLIOGRAPHY

1969 Morphet, Richard, 'London Commentary', *Studio International*, September
 Russell, John, 'In Search of Talent', *The Sunday Times*, 14 September
 Brett, Guy, 'Hinged And Unhinged', *The Times*, 19 September
 Lynton, Norbert, 'More Gaiety for the Nation', *The Guardian*, 1 October

1970 Gosling, Nigel, 'Performing Creations', *The Observer*, 6 September
 Tisdall, Caroline, *The Guardian*, 8 September
 Vaizey, Marina, 'Innovations and Illusions', *The Financial Times*, 22 September
 Denvir, Bernard, 'London Letter', *Art International*, November
 Craig-Martin, Michael, (statement), *The Tate Gallery 1968-70*, Biennial Report and Illustrated Catalogue of Acquisitions

1971 Craig-Martin, Michael, 'A Procedural Proposition: Selection, Repetition, Extension, Exchange', *Studio International*, September
 Shone, Richard: 'Michael Craig-Martin/Artist in Residence', *Varsity*, Cambridge, February

1972 Field, Simon, 'Michael Craig-Martin – An Interview with Simon Field', *Art & Artists*, May
 du Caine, J., 'What are the Intentions Behind your Three Mirror/Light Pieces at the Tate?', *Time Out*, 17 March
 Vaizey, Marina, 'The New Art', *The Financial Times*, 23 March
 Russell, John, 'Wider Horizons', *The Sunday Times*, 12 March
 Packer, William, *Art & Artists*, April
 Gosling, Nigel, 'British Brain Bashers', *The Observer*, 20 August
 Craig-Martin, Michael, (statement), *The Tate Gallery 1970-72*, Biennial Report and Illustrated Catalogue of Acquisitions
 Fuchs, R.H. 'More on the New Art', *Studio International*, November
 Feaver, William: 'London Letter: Summer', *Art International*, November
 Seymour, Anne, *The New Art Catalogue*, Arts Council

1973 Russell, John, 'Cream of Vienna', *The Sunday Times*, 10 June
 Shone, Richard, *Arts Review*, 16 June
 Cork, Richard, 'The Confessional Game Made Easy', *Evening Standard*, 21 June
 Vaizey, Marina, 'Mirror, Mirror on the Wall', *The Financial Times*, 6 July
 Tisdall, Caroline, 'Kidsplay', *The Guardian*, 6 September
 Seymour, Anne, *Henry Moore to Gilbert & George*, Palais des Beaux-Arts, Brussels (catalogue)

1974 Cork, Richard, 'In a Glass of it's Own', *Evening Standard*, 2 May
 Faure Walker, Caryn, *Studio International*, June
 Oille, Jennifer, 'London', *Art & Artists*, July

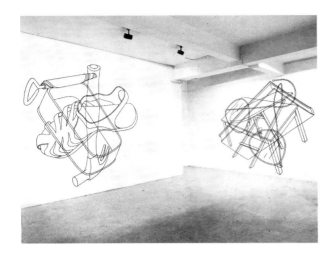

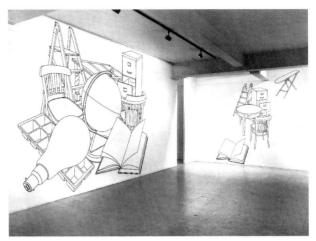

Installation, Rowan Gallery, London, 1978

Installation, Rowan Gallery, London, 1980

Compton, Michael, *Art as Thought Process*, Arts Council
Gosling, Nigel, 'Visible Thinking', *The Observer*,
15 December
'An Interview with Craig-Martin' (An Oak Tree),
Audio Arts, April
Craig-Martin, Michael, (statement), *The Tate Gallery
1972-74*, Biennial Report and Illustrated Catalogue
of Acquisitions

1975 Rorimer, Anne, *Idea and Image in Recent Art*, Art
Institute of Chicago (catalogue)
Rouve, Pierre, 'Art as Thought Process', *Arts Review*,
10 January
del Renzio, Toni, 'Art and/or Language', *Art and
Artists*, 7 December

1976 McEwen, John, 'Art and Paradox', *The Spectator*,
31 July
Mc Dowell, Robert, 'Michael Craig-Martin', *The
Guardian*, 20 August
Chrichton, Fenella, 'London Letter', *Art International*,
October/November
Seymour, Anne, *Michael Craig-Martin: selected works
1966-75*, Turnpike Gallery, Leigh (catalogue)

1977 Coia, Emilio, 'Michael Craig-Martin Exhibition', *The
Scotsman*, 21 January
Oliver, Cordelia, 'Craig-Martin', *The Guardian*,
26 January

Glendon, Patrick, 'The Glass of Water, Oak Tree',
Irish Independent, 16 April
Walker, Dorothy, 'A Little Miracle', *Hibernia*,
29 April
Craig-Martin, Michael, statement, *Art Actuel, Skira
Annuel*, Skira Publications
McEwen, John, 'Hardy Annual', *The Spectator*,
30 July
Vaizey, Marina, 'Best of British', *The Sunday Times*,
31 July
McEwen, John, 'Page Two', *Art Monthly*, September
Lanners, Edi (ed.), *Illusions*, Thames & Hudson Ltd.

1978 McEwen, John, 'Michael Craig-Martin', catalogue
essay, *Michael Craig-Martin*, Museum of Modern Art,
Brisbane
Craig-Martin, Michael, 'Taking things as Pictures',
Artscribe, no. 14, October
McEwen, John, 'Eye Deceiving', *The Spectator*,
28 October
McEwen, John, 'Abstract Prizes', *The Spectator*,
9 December
Searle, Adrian, 'Michael Craig-Martin, Paul Huxley
at the Rowan', Reviews, *Artscribe*, no. 15, December

1979 'Un Certain Art Anglais', *Arts Review*, 2 March
Walker, Dorothy, 'Reviews and Previews', *Art about
Ireland*, December/January

1980 Feaver, William, 'The State of British Art: It's a Bewilderment', *Artnews*, January
Shone, Richard, 'London, Rowan Gallery, Michael Craig-Martin', *The Burlington Magazine*, March
McEwen, John, 'Taped', *The Spectator*, 29 March

1981 Searle, Adrian, 'Michael Craig-Martin', *Art Forum*, Summer

1982 Brown, David, 'Aspects of British Art Today', Tokyo/The British Council (exhibition catalogue)
Lynton, Norbert, 'Michael Craig-Martin', New Dehli/The British Council (exhibition catalogue)

1983 Shone, Richard, 'London Exhibitions', *The Burlington Magazine*, February

1984 Thompson, Jon, '*The British Art Show*', The Arts Council/Orbis (catalogue essay)

1985 Oille, Jennifer, 'Michael Craig-Martin: Waddington and Shiell', *Vanguard*, December/January
Shone, Richard, *Michael Craig-Martin* (introduction), Waddington Galleries, London (catalogue)
Feaver, William, 'Pouring the gravy', *The Observer*, 10 February

1987 Ehrlich, Jane, 'A View from Mid Atlantic', *The American*, 7 August

1988 Beaumont, Mary Rose, 'Michael Craig-Martin: Waddington Galleries', *Arts Review*, 11 March, p. 165
Heath, Adrian, 'Concerning Conceptualism', *Art Monthly*, February, p. 4-6
Batchelor, David, 'Michael Craig-Martin, Waddington', *International Artscribe*, Summer
Craig-Martin, Michael, 'Reflections on the 1960s and early '70s, *Art Monthly*, March
Archer, Michael, 'Michael Craig-Martin: Waddington Galleries', *Artforum*, Summer
Cooke, Lynne, 'Identify the Object', *Art International*, Summer
Shone, Richard, 'Exhibition Reviews – Waddington Galleries', *The Burlington Magazine*, April
Gooding, Mel, 'Craig-Martin; Charlton; Hayman', *Art Monthly*, April, p. 11

PHOTOGRAPHS

Frontispiece: Michael Craig-Martin
page 14 a, courtesy the Saatchi Collection, London
page 14 b, plate nos. 5+6: Tate Gallery, London
page 15 a+b: Eileen Tweedy
page 19 a: Simon Wilson
page 20 a+b, 24 b, plate nos. 1-4, 7-26, 28-41: Prudence Cuming Associates
page 24 a: Mark James
plate no. 27: Edward Woodman
Portrait of the artist, page 68: Jerry Young
page 108: The artist installing *Reading (with Globe)*, 1980, at the Tate Gallery in 1980, courtesy *The Times*
page 123 a+b, page 124, page 126 a+b: John Webb

Catalogue published by the Trustees of the Whitechapel Art Gallery, London
© The Authors and the Trustees of the Whitechapel Art Gallery, 1989
Edited by Joanna Skipwith
Designed by Kate Stephens
Printed in Holland by Lecturis bv, Eindhoven
2000 copies printed and paperbound
ISBN 0 85488 086 0

The Whitechapel Art Gallery opened in 1901 and is administered by a charitable trust. The trust has no endowment and the Gallery's existence and programme therefore depend wholly on financial assistance given by national and local authorities, companies (through sponsorship and donations), foundations, trusts and individuals. In 1984, the Whitechapel Art Gallery Foundation was established to stimulate support from the business community and charitable sector.

The Whitechapel gratefully acknowledges the financial assistance which it has been receiving from:

Arts Council of Great Britain
Greater London Arts
London Borough of Tower Hamlets
London Docklands Development Corporation
London Boroughs Grants Scheme
Inner London Education Authority

FOUNDATIONS AND TRUSTS

Adeby Charitable Trust
Aldgate and Allhallows, Barking Exhibition Foundation
The Charterhouse Charitable Trust
The Chase Charity
City of London Polytechnic
Cripplegate Foundation
Draper's Company
The Henry Moore Foundation
Mercer's Company
Ruskin's Guild of St. George
Sir John Cass's Foundation
Visiting Arts

SPONSORS

Bankers Trust Company
Barclays Bank plc.
British Petroleum Company plc.
CBS Music Video Enterprises
Citicorp/Citibank
Jamdani, Charlotte Street
Midland Bank
Montblanc
Stanhope Properties plc.
Unilever

DONORS

Arthur Anderson & Co.
Banca Commerciale Italiana
Bovis Construction Ltd.
British Airways
British Gypsum Ltd.
British Telecom
Conder Group plc.
Davis Langdon & Everest
Gardiner Theobald
Granada Group plc.
Healy & Baker
Herbert Smith
Industrial Acoustics Company Ltd.
Invest Limited
John Laing Construction Limited
McKenna & Co.
Mercury International Group plc.
Ove Arup Partnership
The Peninsular & Oriental Steam Navigation Company
Roy Properties Ltd.
Save & Prosper Group
Sir Robert McAlpine & Sons Ltd.
Sir Robert & Lady Sainsbury
Mr Harold Schiff
Trusthouse Forte plc.
Virgin Communications Ltd.
Waddington Galleries Ltd.
Wolff Olins

CORPORATE PATRONS

Arthur Anderson & Co. Foundation
Blackburn Associates Ltd.
Blackwall Green Ltd.
Botts and Company Ltd.
Cable and Wireless plc.
Citicorp/Citibank
City Acre Property Investment Trust
Continental Bank
Credit Suisse First Boston Ltd.
Crowley Colosso Ltd.
Deutsche Bank AG London Branch
Drexel Burnham Lambert
Eagle Star
Euromoney
Fischer Fine Art Ltd.
Fletcher King
Friends Provident
Granada Group plc.
Grand Metropolitan Brewing Ltd.
Hanover Acceptances
Henry Ansbacher & Co. Ltd.
House of Fraser plc.
IBM United Kingdom Trust
John Crowther Group plc.
Jones Lang Wootton
The Members of Lloyd's & Lloyd's Brokers
Midland Bank
JP Morgan
Morgan Stanley International
National Investment Group plc.
National Westminster Bank plc.
Nomura Bank International plc.
Oppenheimer Charitable Trust
Pearson plc.
Pirelli UK
Queen Mary College
Romulus Construction Ltd.
Saatchi & Saatchi Company plc.
Salomon Brothers International Ltd.
Save & Prosper Group
Sedgwick Group plc.
Sheppard Robson
Sheraton Securities plc.
Sotheby's
Steggles Palmer
Sun Life Assurance Society plc.
Taylor Woodrow Group
Thames Television plc.
Trafalgar House plc.
Waddington Galleries Ltd.
Williams Lea & Co. Ltd.

CORPORATE ASSOCIATES

Alex Reid & Lefevre Ltd.
Annely Juda Fine Art
Anthony d'Offay Gallery
The Bank of England
BET plc.
Charrington & Company
Christie, Manson & Woods Ltd.
Coutts & Co.
Deloitte, Haskins & Sells
Edward Totah Gallery
The Fine Art Society
Friends Provident Life Office
Galerie Maeght Lelong, New York
Goldman Sachs International Corp
Intercom Data Systems
The International Stock Exchange
Lisson Gallery London Ltd.
Marlborough Fine Art (London) Ltd.
Mayor Gallery Ltd.
Mayor Rowan Gallery
Morgan Grenfell & Co. Ltd.
MoMart Ltd.
Nicola Jacobs Gallery
Peat Marwick McLintock
The Rank Organisation plc.
Robert Fleming Holdings Ltd.
Royal Life Holdings Ltd.
SG Warburg & Co. Ltd.
Thames and Hudson Ltd.
Victoria Miro Gallery, London

128